PICTURES BY J.R.R. TOLKIEN

PICTURES BY

J.R.R. Tolkien

Foreword and notes by
CHRISTOPHER TOLKIEN

Houghton Mifflin Harcourt
Boston New York

First published by HarperCollins*Publishers* 1992

First published in Great Britain by
George Allen & Unwin 1979

For information about how to reproduce selections from this book,
write to trade.permissions@hmhco.com or to Permissions,
Houghton Mifflin Harcourt Publishing Company, 3 Park Avenue,
19th Floor, New York, New York 10016.

hmhbooks.com
tolkienestate.com

ISBN 978-0-358-65304-2

4500843988

CONTENTS

FOREWORD

The primary purpose of this book is to collect together all the pictures (paintings, drawings, designs) by J.R.R. Tolkien which were published in a series of six calendars from 1973 to 1979, with a gap in 1975.

The first of these calendars was published in America by Ballantine Books, and while this contained the five paintings in *The Hobbit* it also included some hitherto unknown pictures to illustrate *The Lord of the Rings* (in this book nos. 21, 22, 24, and 30) and a sketch for a painting of the death of Smaug the Dragon over the flames of Lake-town (19).

In 1974 began the series of calendars published by George Allen and Unwin; and this one was prepared during my father's lifetime. It contained many of the same pictures as that of 1973, but also a further illustration to *The Lord of the Rings* (25), the painting of Taniquetil (31) – an illustration to *The Silmarillion* done some forty years before the posthumous publication of the book – and a painting (37) which though entitled 'Fangorn Forest' is in fact quite certainly of a scene in *The Silmarillion*.

After my father's death Mr Rayner Unwin, Chairman of Allen and Unwin, proposed to me that we should continue the series of calendars, and we collaborated closely in the selection and presentation of pictures for those of 1976–1979. For *The Hobbit Calendar 1976* the five paintings published in *The Hobbit* were again reproduced, but for the remaining seven months Mr H.E. Riddett was invited to colour the pen and ink pictures; and since then these coloured versions have appeared elsewhere.

For *The Lord of the Rings Calendar 1977* it seemed to us that a precedent had been set by my father's approval of the publication of the unfinished

sketch of 'The Death of Smaug' in the calendars for 1973 and 1974, and in addition to finished illustrations, most of which had appeared previously, we included unfinished sketches and rapid vignettes of great interest as an indication of the author's conception of certain places, as Helm's Deep, Orthanc, and Cirith Ungol (26–28). The nature of some of these pictures, and most especially the burnt leaves from the Book of Mazarbul (23 [now 24]), seemed to call for an explanatory comment, and to this calendar (and the subsequent ones) I contributed notes, some of which reappear in this book.

The Silmarillion Calendar 1978 was mainly illustrated by paintings and drawings done in the late 1920s, when *The Silmarillion* was still young (only two of these, 31 and 37, had appeared previously), and the drawings were coloured by Mr Riddett (34–36). Also included were three examples of Elvish script, and the 'heraldic' devices borne by figures of the First Age, the Age of *The Silmarillion*.

The J.R.R. Tolkien Calendar 1979, the last of the series, was also largely composed of previously unpublished paintings and designs, and included four further illustrations to *The Hobbit* (3, 11, 13, 18, the first of these coloured by Mr Riddett), together with a coloured version of 'The Hall at Bag-End' (20). It showed examples of formal or emblematic dragons, trees, and flowers, presented in decorative arrangements that in some cases combine elements from widely separated times.

As I have said, this book was conceived as a collection of all the pictures that appeared in the six calendars; but various considerations led us somewhat to extend its scope. In the first place, it seemed desirable to include the original pen and ink illustrations published in *The Hobbit*,

facing the coloured versions that Mr Riddett made for the calendars (2, 7, 8, 10, 12, 15, 16, 20); and this naturally led to the inclusion of the originals of the unpublished pictures coloured by Mr Riddett – these originals (3, 34–36) here appearing for the first time.

In the second place, a collection of all the pictures from the calendars necessarily constitutes a fairly complete record of my father's published work (since the majority of them first appeared in the calendars, while the calendars included almost everything that had been published previously – the chief exception being the illustrations of *The Father Christmas Letters*). I have therefore more nearly approached completeness by the inclusion of a few things that did not appear in the calendars: the pen and ink drawing of Hobbiton (1), the Doors of Durin (22), Mirkwood (37), and the tree on the cover of the first paperback edition of *Tree and Leaf* (41). The illustrations of *The Father Christmas Letters* have not been repeated, with the exception of the 1928 picture of the Polar Bear fallen to the foot of the stairs in Father Christmas' house (39), which was used in the 1979 calendar.

These enlargements of scope are however very minor. The book remains closely related to the calendars, which were limited (with a few exceptions among the designs in that of 1979) to pictures illustrating *The Hobbit*, *The Lord of the Rings*, and *The Silmarillion*; and the range of my father's pictorial art, especially that of his earlier years, is by no means fully represented here.

Christopher Tolkien, 1979

PREFACE TO THE PRESENT EDITION

In this edition the illustrations remain entirely unchanged, apart from this rectification of an unfortunate error in the case of no. 1, The Hill: Hobbiton-across-the Water. The drawing of Hobbiton that was the frontispiece to the first impression of *The Hobbit* was to face the watercolour of the same scene that appeared in the second impression, and my note so described it; but it was not until it was too late that I discovered that an unpublished sketch of Hobbiton had been substituted (in which, contrary to what is said in the note, there are no words at all on the signpost).

I have however taken the opportunity to correct or enlarge certain of the notes accompanying the pictures, chiefly in the case of the illustrations to *The Lord of the Rings*: thus my radical misinterpretation of no. 23 (formerly no. 24) is rectified, while the significance of the representations of Shelob's Lair (28) and Dunharrow (29) has now been made clear in my account of the writing of *The Lord of the Rings* in *The History of Middle-earth*.

The book remains, however, what it was in its inception: a collection of those of my father's pictures and sketches that appeared in the series of calendars, with notes of a primarily documentary nature, and it does not go beyond that.

Christopher Tolkien, 1992

PUBLISHER'S NOTE

This reissue of *Pictures by J.R.R. Tolkien* in 2021 brings back into print a book that has been unavailable for more than a quarter of a century. Since it was first published in 1979, and revised in a second edition of 1992, much has changed in the field of colour reproduction and, with the kind assistance of The Bodleian Library, University of Oxford, new digital scans allow for the many paintings, drawings and sketches produced by J.R.R. Tolkien and selected by his son, Christopher, to be reproduced here for the first time as faithful reproductions of the original works. Presenting this fine collection for a new generation of readers, the publishers would like to respectfully dedicate it to the memory of Christopher Tolkien and his father, J.R.R. Tolkien.

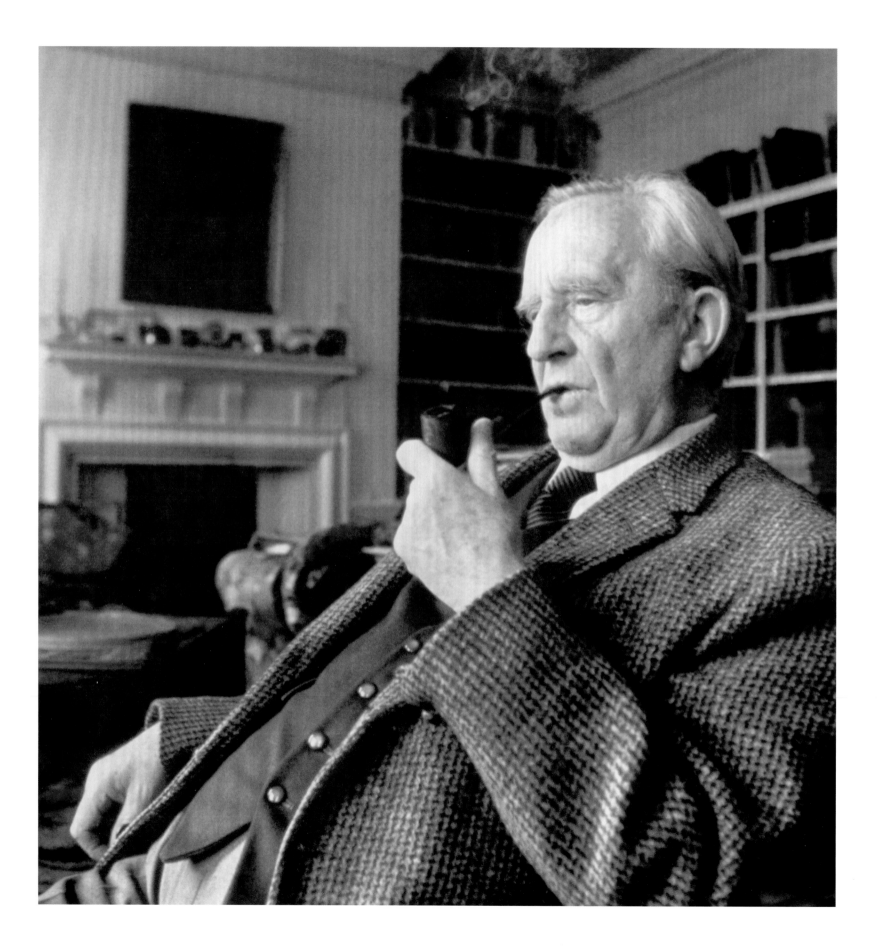

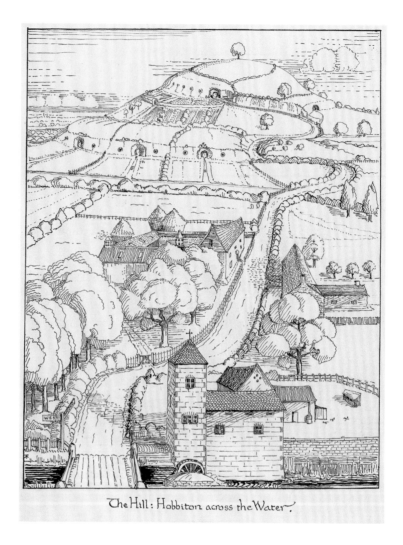

The Hill: Hobbiton across the Water

1. *The Hill: Hobbiton-across-the Water*

The drawing of Hobbiton was the frontispiece to the original impression of *The Hobbit*, 1937, which had no coloured pictures, and it has not been published since (see the introductory note to this edition). The painting appeared as frontispiece to the second English impression of the same year, and in the first American edition, 1938.

There are only very slight differences between the two renderings, most notably in the windows of the mill and in the words on the signpost, which in the drawing directs the traveller to Bag-End but in the painting to the Hill.

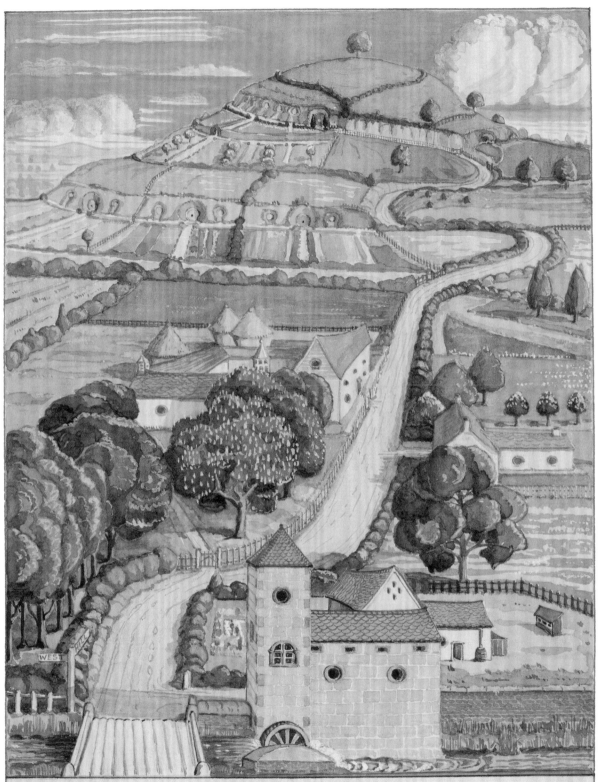

The hill : hobbiton-across-the Water

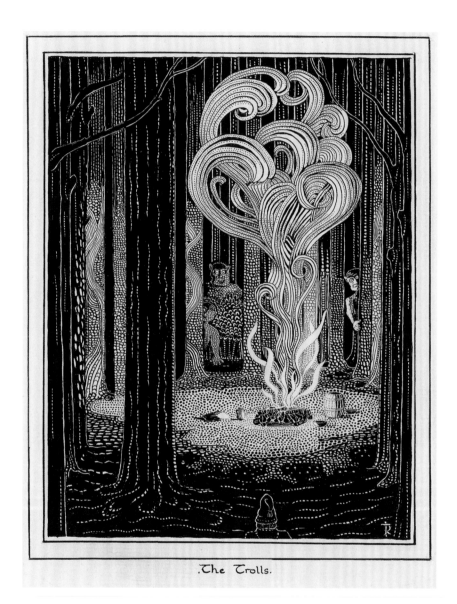

.The Trolls.

2. *The Trolls*

The original was published in the first impression of *The Hobbit*, 1937 (in Chapter 2, *Roast Mutton*). The coloured version by H.E. Riddett was made for *The Hobbit Calendar 1976*, and has been used in some illustrated editions of the book.

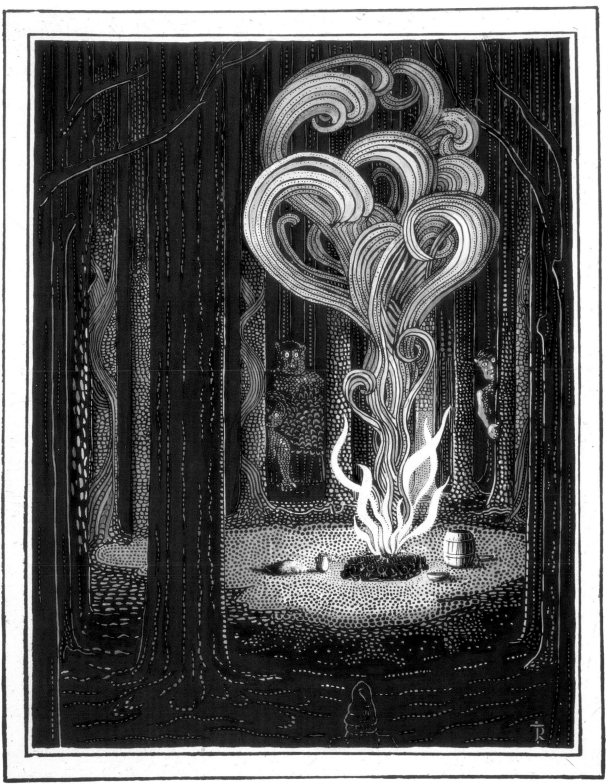

The Trolls

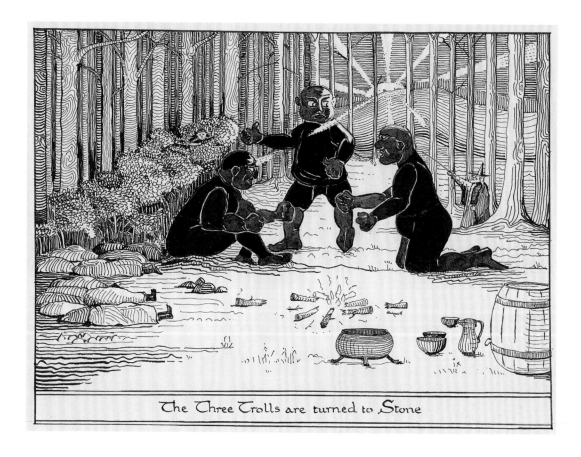

The Three Trolls are turned to Stone

3. *The Three Trolls are turned to Stone*

This drawing to illustrated Chapter 2 of *The Hobbit* has not been previously published, but the coloured version by H.E. Riddett appeared in *The J.R.R. Tolkien Calendar 1979*.

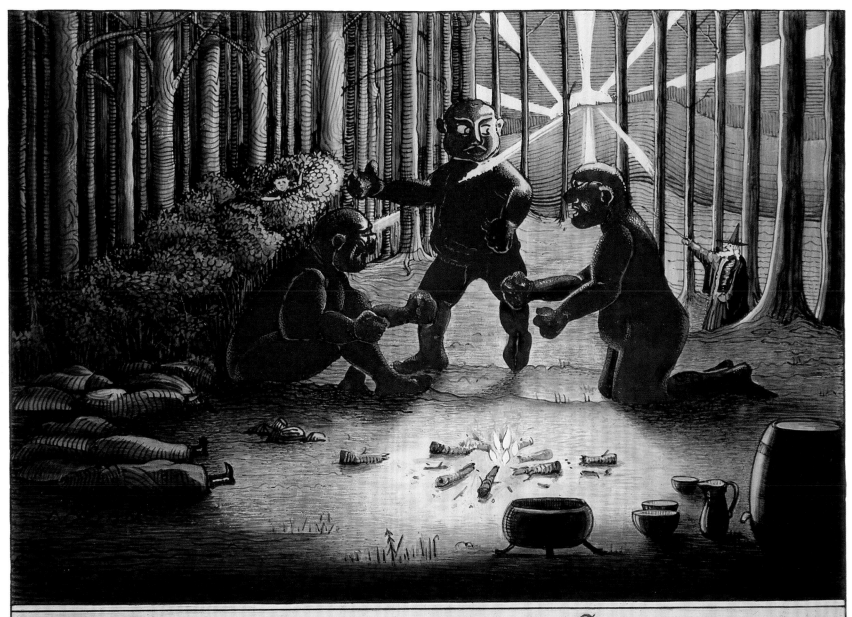

The Three Trolls are turned to Stone

4. *Rivendell (I)*

This unfinished crayon sketch (published in *The Lord of the Rings Calendar 1977*) is puzzling. The words 'looking West' are, as can be seen, perfectly clear, and the placing of Elrond's house in relation to the river agrees with this (see nos. 5 and 6); but the river is then flowing steeply down out of heights to the westward. See the note to no. 5.

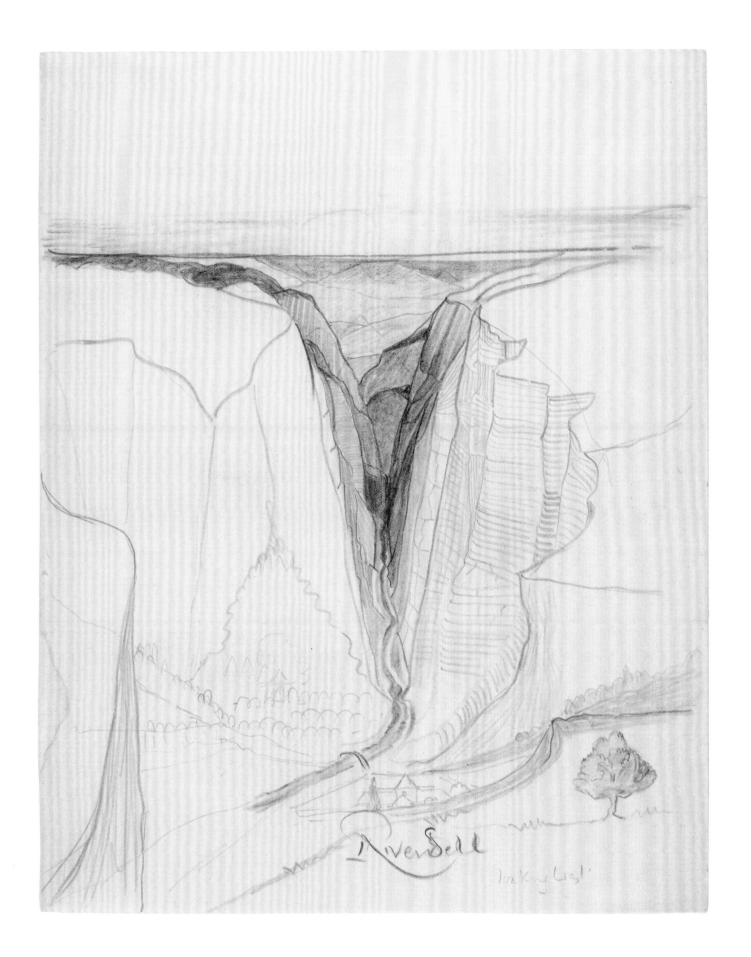

Rivendell

5. *Rivendell (II)*

In the original edition of this book I described this picture in crayon (published in *The Lord of the Rings Calendar 1977*) as an earlier conception of the view of Rivendell looking east towards the Misty Mountains than that in the watercolour published in *The Hobbit* (no. 6). It now seems to me to be possible, however, from the style of the picture, that it was in fact later than the watercolour, and belongs (as also no. 4) with the illustrations to *The Lord of the Rings*.

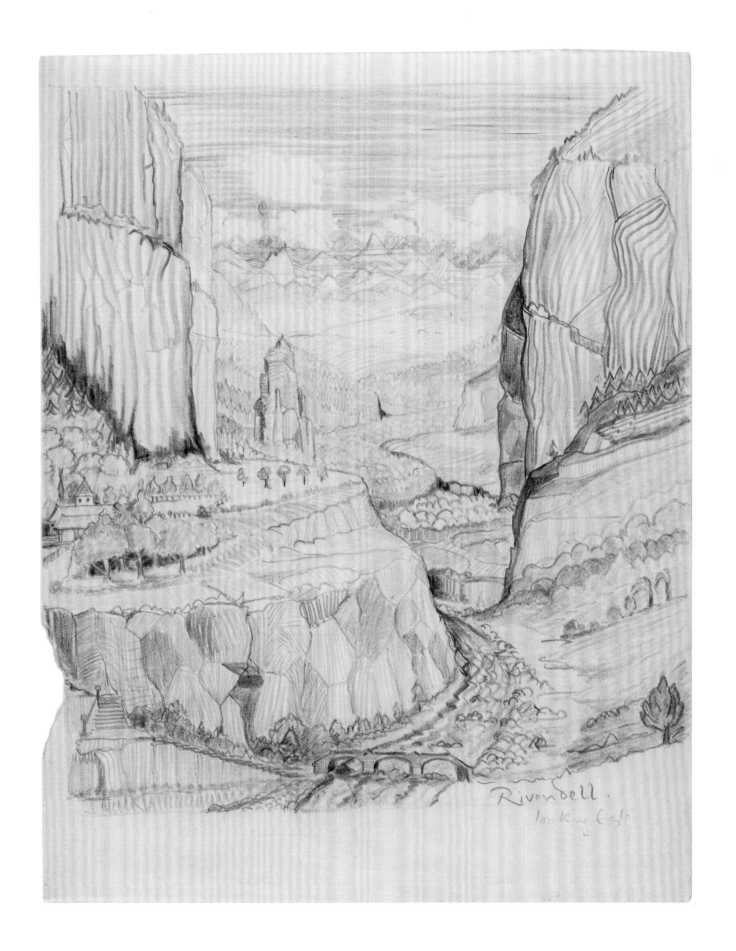

Rivendell.
looking East

6. *Rivendell (III)*

Not used in the original impression of *The Hobbit*, 1937, which included no coloured illustrations, this painting appeared in the second impression of the same year, and in the first American edition, 1938. In the American edition the title 'Rivendell' within the decorative border was removed (on which my father commented: 'I cannot imagine why they have spoilt the Rivendell picture by slicing the top and cutting out the ornament at the bottom'), but both reproductions carried the printed caption 'The Fair Valley of Rivendell' ('Hidden somewhere ahead of us is the fair valley of Rivendell were Elrond lives in the Last Homely House', Chapter 3, *A Short Rest*).

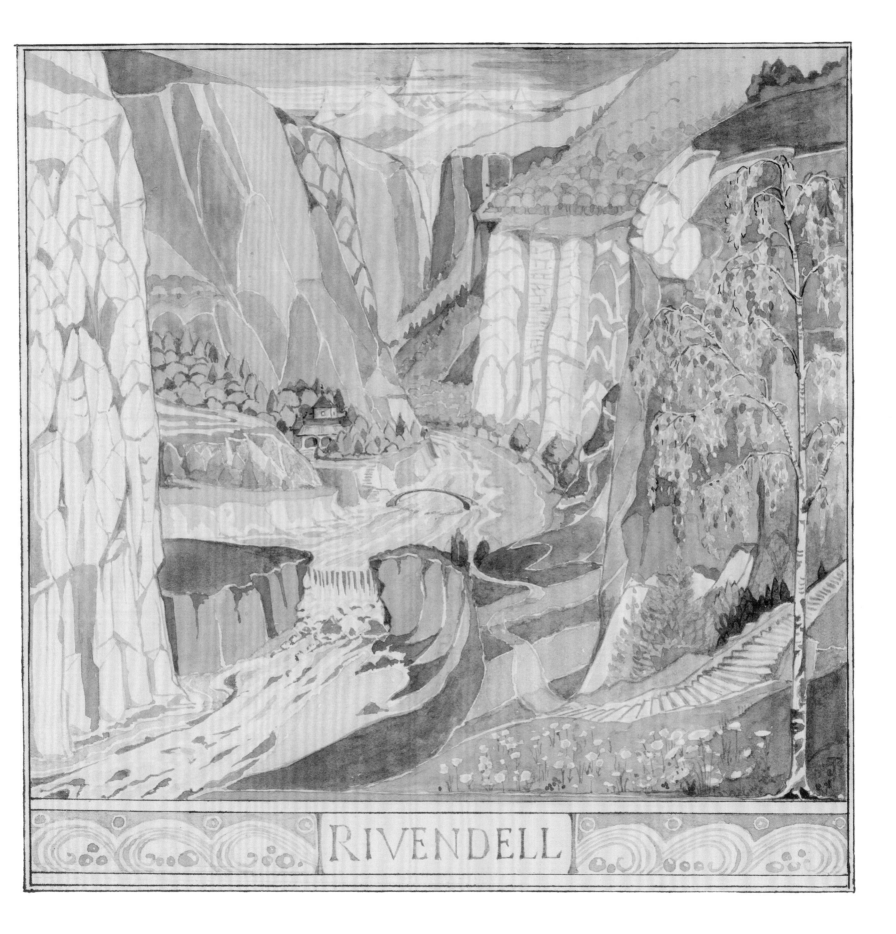

RIVENDELL

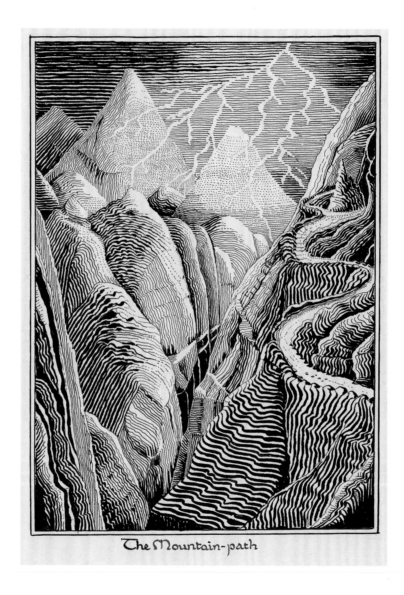

The Mountain-path

7. *The Mountain-path*

The original was published in the first impression of *The Hobbit*, 1937, (in Chapter 4, *Over Hill and Under Hill*). The coloured version by H.E. Riddett was made for *The Hobbit Calendar 1976*, and has been used in some illustrated editions of the book.

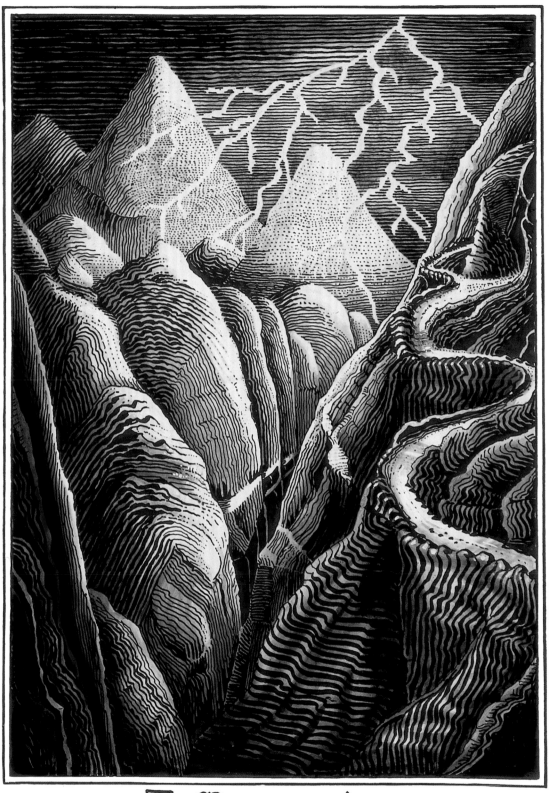

The Mountain-path

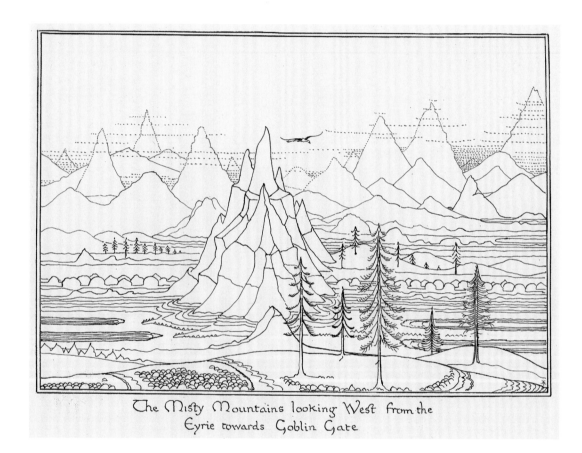

The Misty Mountains looking West from the Eyrie towards Goblin Gate

8. *The Misty Mountains looking West from the Eyrie towards Goblin Gate*

The original was published in the first impression of *The Hobbit*, 1937, (in Chapter 6, *Out of the Frying-Pan into the Fire*). The coloured version by H.E. Riddett was made for *The Hobbit Calendar 1976*, and has been used in some illustrated editions of the book.

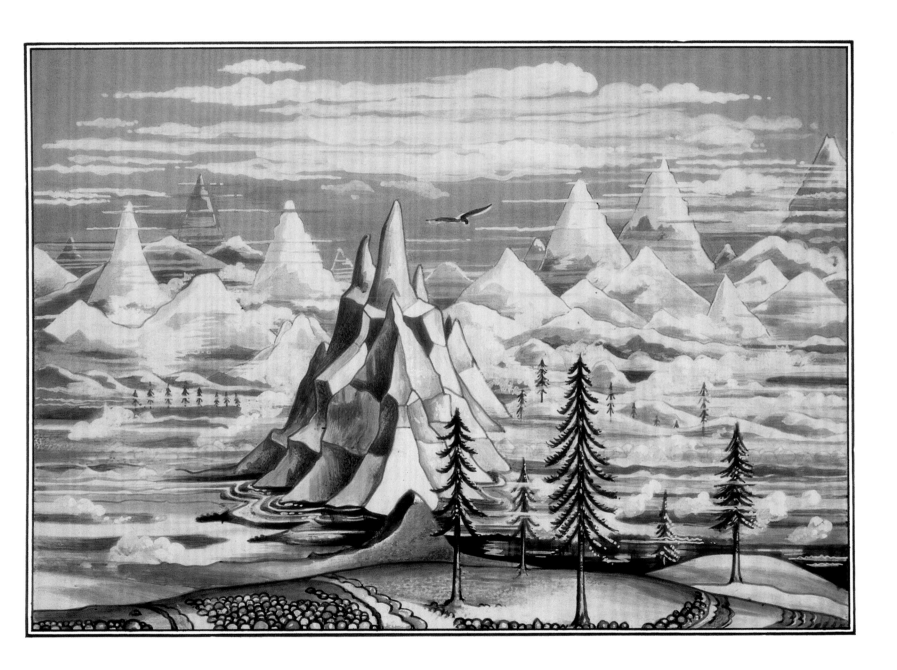

9. *Bilbo woke with the early sun in his eyes*

This painting, to illustrate the first words of Chapter 7 of *The Hobbit* (*Queer Lodgings*), was not used in the first English impression to contain coloured pictures, but appeared in the first American edition, 1938. The eagle was inspired by the painting of an immature Golden Eagle by Archibald Thorburn.

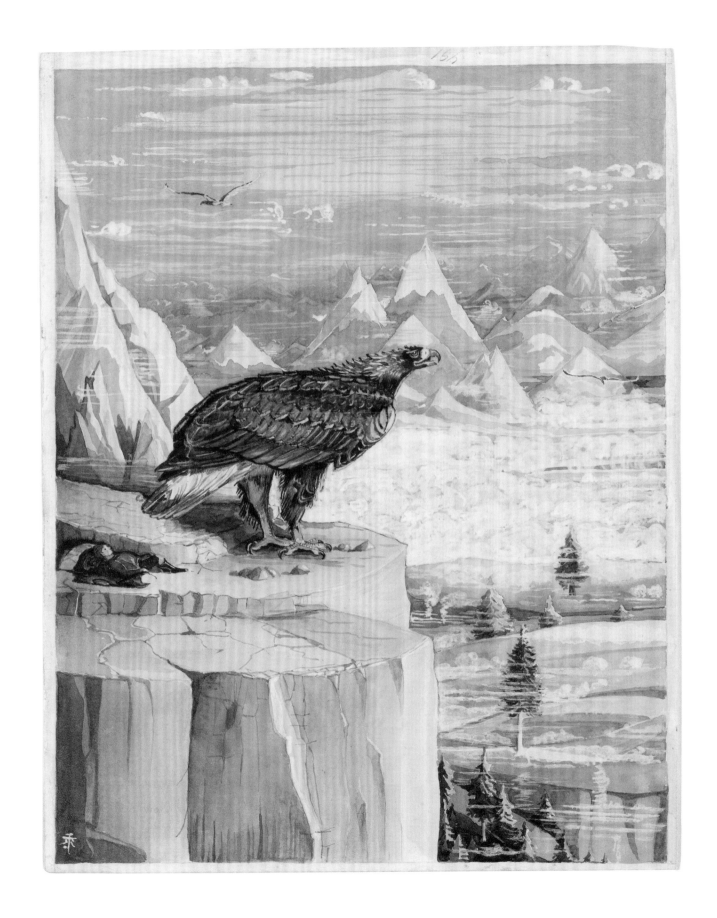

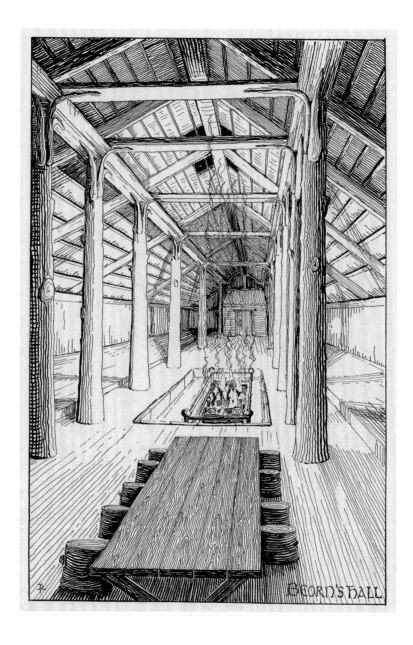

10. *Beorn's Hall*

The original was published in the first impression of *The Hobbit*, 1937, (in Chapter 7, *Queer Lodgings*). The coloured version by H.E. Riddett was made for *The Hobbit Calendar 1976*, and has been used in some illustrated editions of the book.

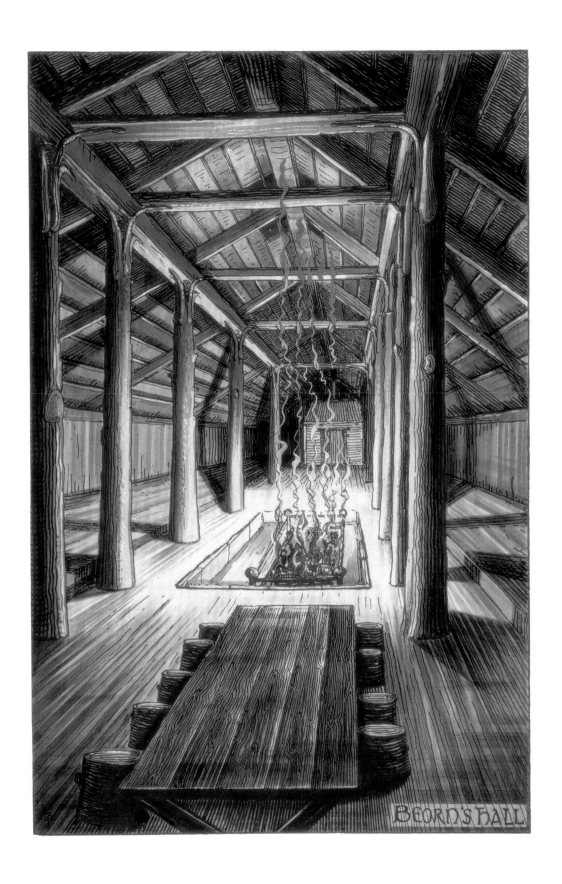

11. *The Elvenking's Gate (I)*

An unfinished painting to illustrate *The Hobbit*, Chapter 9 (*Barrels out of Bond*). It was published in *The J.R.R. Tolkien Calendar 1979*. See no. 12.

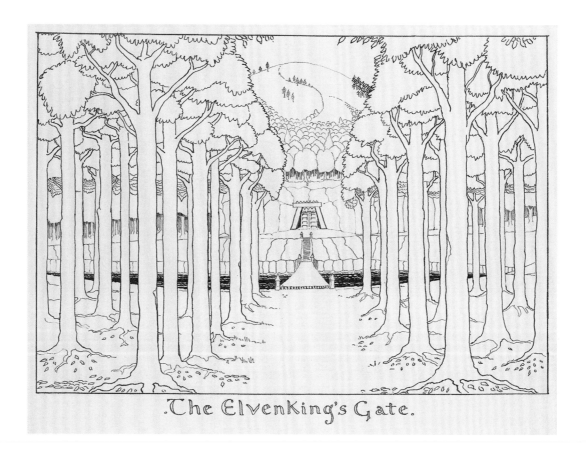

.The Elvenking's Gate.

12. *The Elvenking's Gate (II)*

The original was published in the first impression of *The Hobbit*, 1937, (in Chapter 9, *Barrels out of Bond*). The coloured version by H.E. Riddett was made for *The Hobbit Calendar 1976*, and has been used in some illustrated editions of the book.

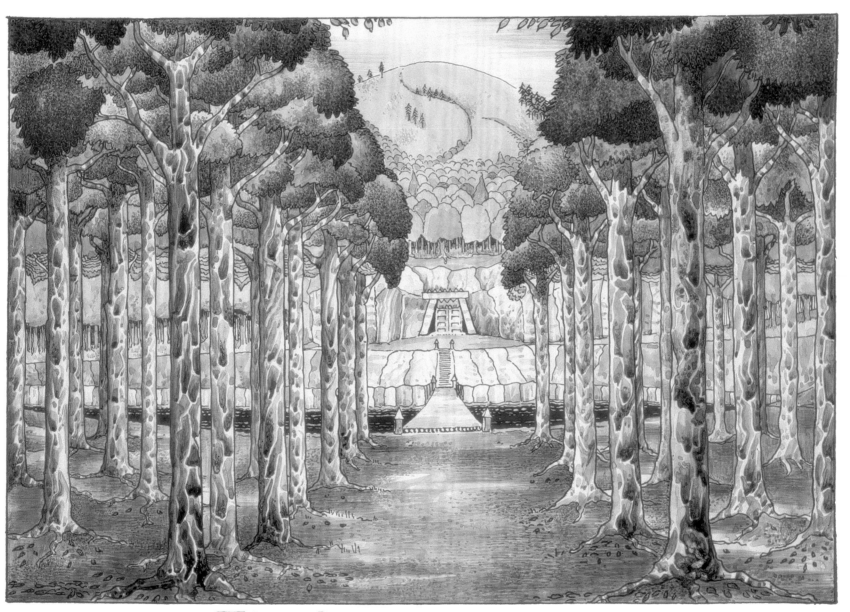

.The ElvenKing's Gate.

13. *Bilbo Comes to the Huts of the Raft-elves (I)*

This painting, with the inscription 'Sketch for the Forest River, Hobbit Ch. IX', shows Bilbo's arrival on the barrel by the full moon, whereas in the painting published with the book the sun has already risen (see no. 14). In the text the barrels arrived at the village of the Raft-elves while it was still dark. 'There was a dim sheet of water no longer overshadowed, and on its sliding surface there were dancing and broken reflections of clouds and stars.' This picture was published in *The J.R.R. Tolkien Calendar 1979*. The paper of the original is torn on the lower left-hand side and a blue underlay shows here.

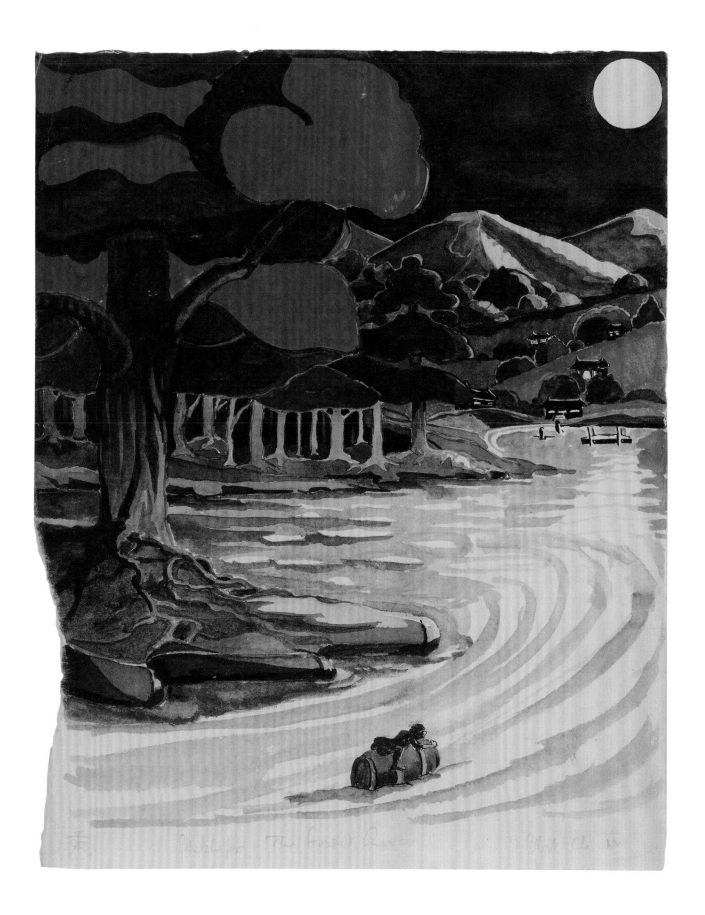

14. *Bilbo Comes to the Huts of the Raft-elves (II)*

See no. 13. Not used in the original impression of *The Hobbit*, 1937, which included no coloured illustrations, this painting appeared in the second English impression of the same year. It was the only one of the five submitted that was not used in the first American edition, 1938. In a letter written to the American publishers in March 1938 my father, while approving their use of 'the Eagle picture' (no. 9, omitted from the first English impression to contain coloured illustrations), said that he was sorry that they had not selected 'the River picture, in which on the whole the amateur artist caught the imagined scene most closely'. In the second English impression the picture carried the printed caption 'The dark river opened suddenly wide' (from Chapter 9, *Barrels out of Bond*).

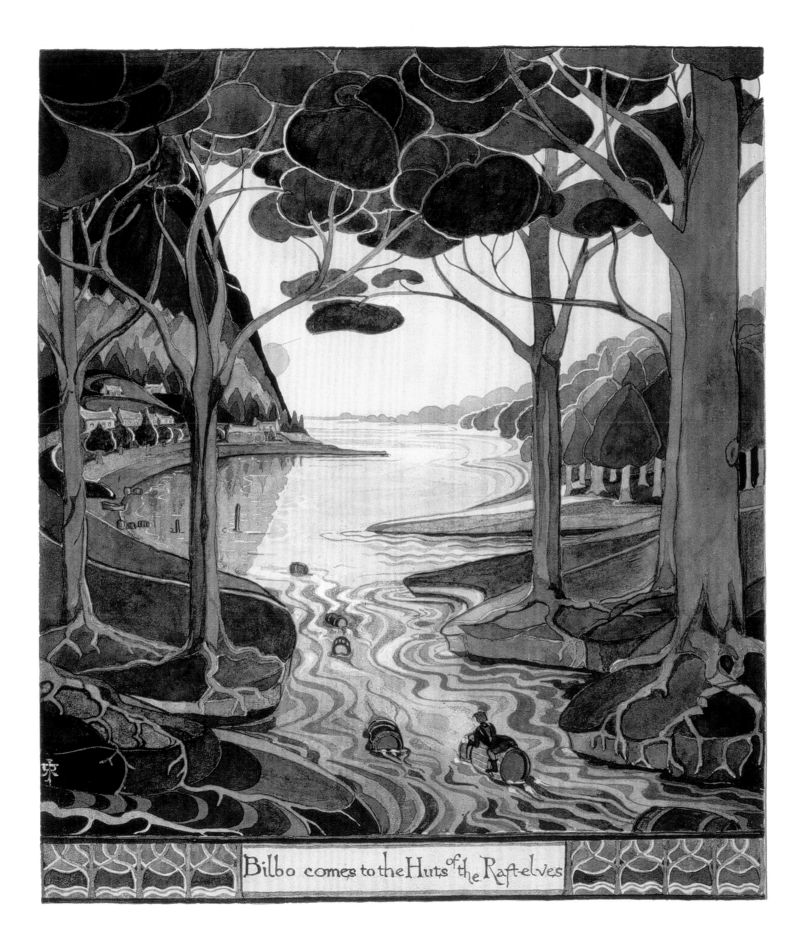

Bilbo comes to the Huts of the Raft-elves

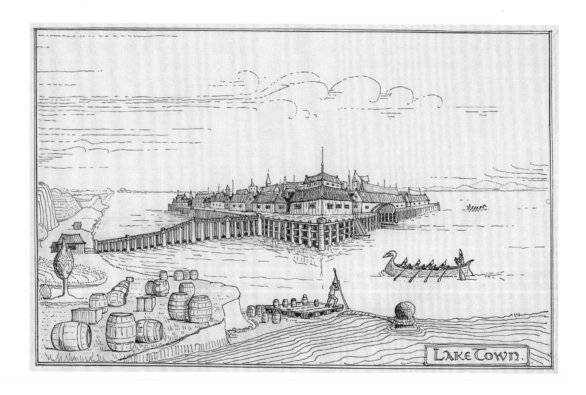

15. *Lake Town*

The original was published in the first impression of *The Hobbit*, 1937, (in Chapter 10, *A Warm Welcome*). The coloured version by H.E. Riddett was made for *The Hobbit Calendar 1976*, and has been used in some illustrated editions of the book.

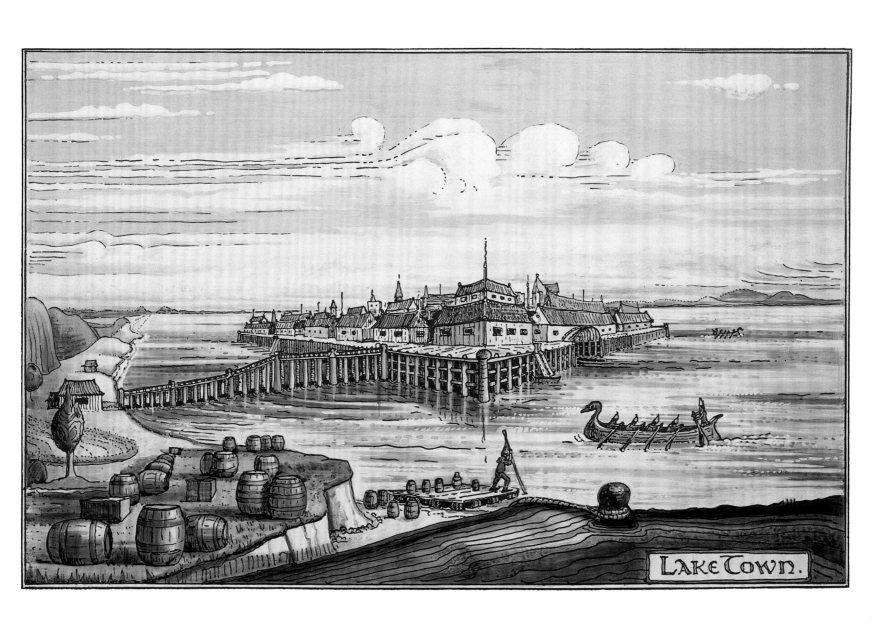

LAKE TOWN.

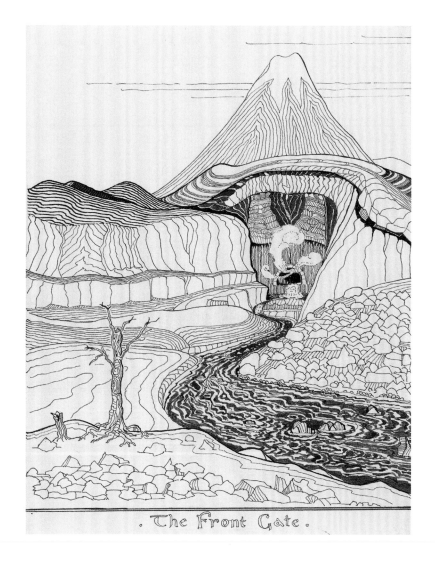

. The Front Gate .

16. *The Front Gate*

The original was published in the first impression of *The Hobbit*, 1937, (in Chapter 11, *On the Doorstep*). The coloured version by H.E. Riddett was made for *The Hobbit Calendar 1976*, and has been used in some illustrated editions of the book.

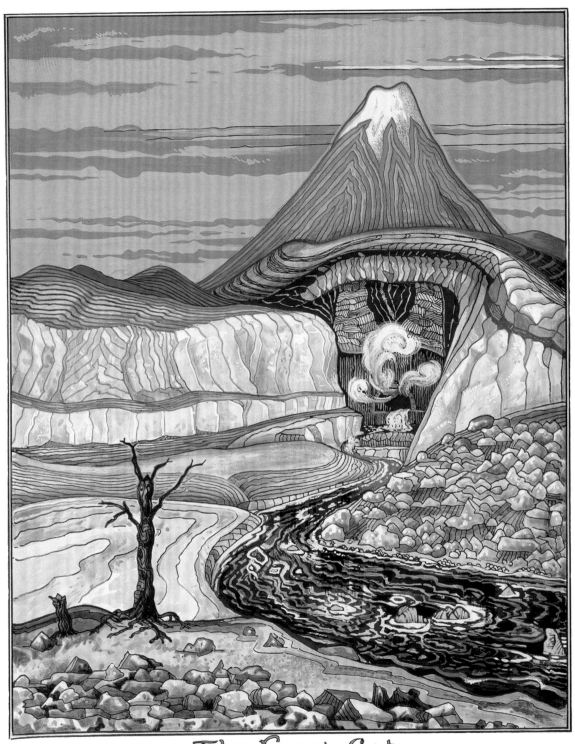

. The Front Gate .

17. *Conversation with Smaug*

Not used in the original impression of *The Hobbit*, 1937, which included no coloured illustrations, this painting appeared in the second English impression of the same year and in the first American edition, 1938. In the American edition the title and the J.R.R.T. monogram were obliterated; but both reproductions carried the printed caption 'O Smaug the Chiefest and Greatest of Calamities' (Bilbo's words to the Dragon, Chapter 12, *Inside Information*).

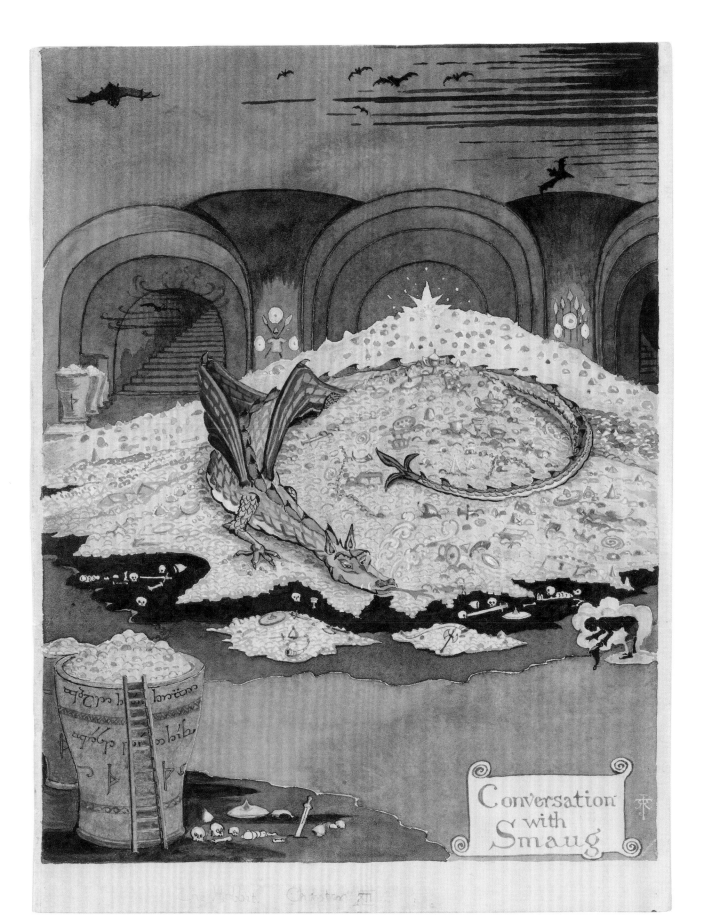

Conversation with Smaug

18. *Smaug flies round the Mountain*

This painting of the Lonely Mountain, which shows the ruins of the town of Dale in the bend of the Running River, was published in *The J.R.R. Tolkien Calendar 1979.*

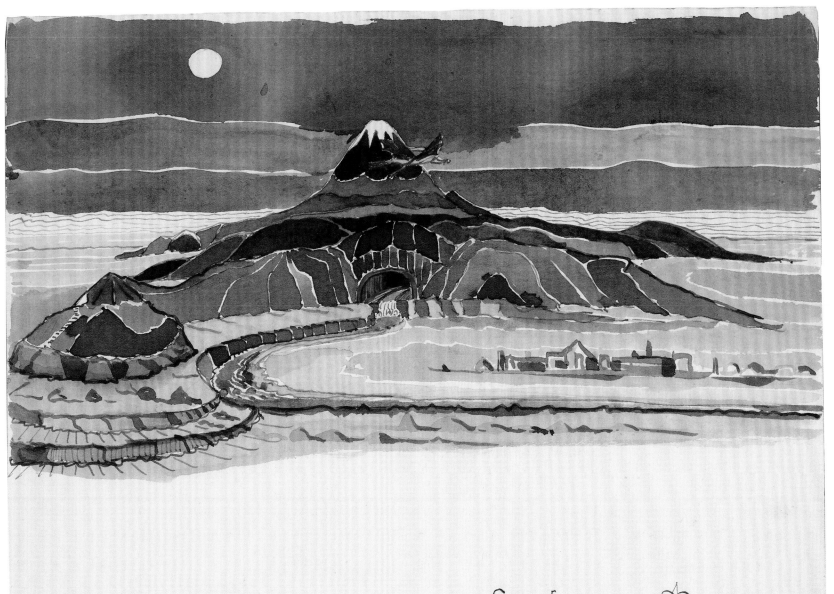

Smaug flies round the Mountain.

19. *Death of Smaug*

This sketch of the arrow shot by Bard the Bowman finding its mark in the Dragon's belly above burning Lake Town (*The Hobbit*, Chapter 14, *Fire and Water*) was published in *The J.R.R. Tolkien Calendars 1973* and *1974*. The writing on the left side of the picture reads: 'The moon should be a *crescent*: it was only a few nights after the *New Moon* on Durin's Day'; in the left-hand bottom corner: 'Dragon should have a white *naked* spot where the arrow enters'; and at the bottom: 'Bard the Bowman should be standing after release of arrow at extreme left point of the piles.'

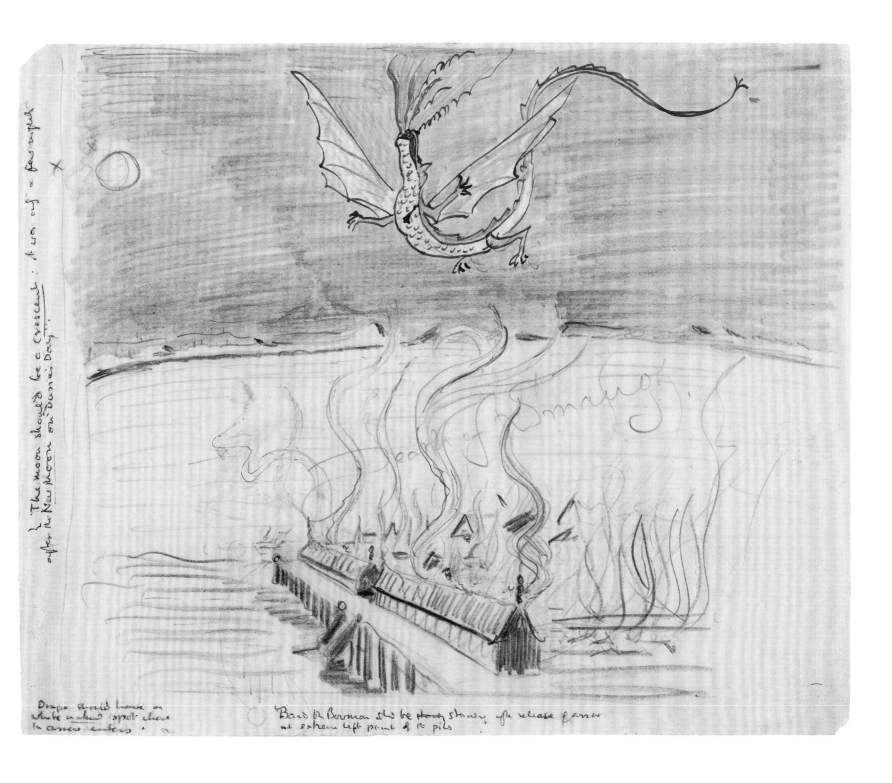

The moon should be a crescent: It was only a few nights after the New Moon on Durin's Day.

Dragon should have a white underside except where in armour enters.

Bard the Bowman should be standing, showing after release of arrow at extreme left point of the pile.

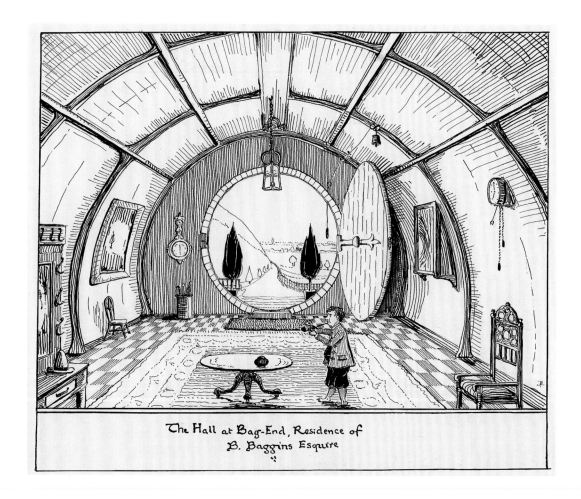

The Hall at Bag-End, Residence of
B. Baggins Esquire

20. *The Hall at Bag-End, Residence of B. Baggins Esquire*

The original was published in the first impression of *The Hobbit*, 1937, (in Chapter 19, *The Last Stage*). The coloured version by H.E. Riddett was first published in the English De Luxe edition and in a new edition of the Dutch translation (both 1976), and appeared also in *The J.R.R. Tolkien Calendar 1979*.

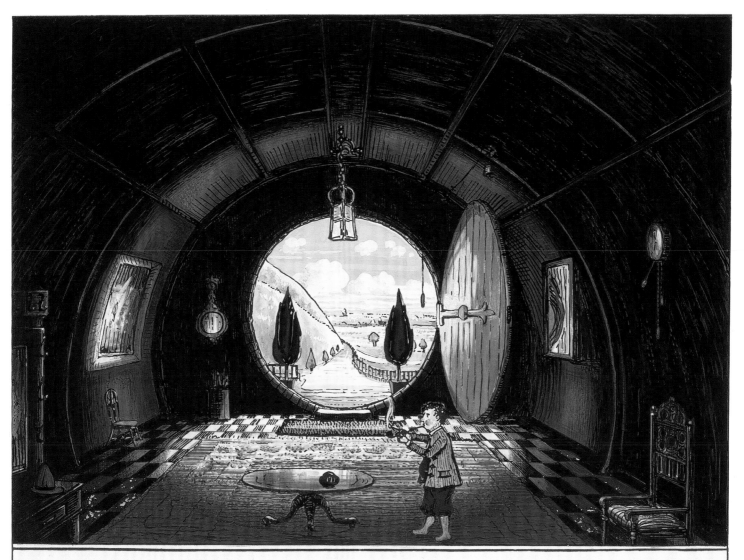

The Hall at Bag-End, Residence of
B. Baggins Esquire

21. *Old Man Willow*

Crayon drawing to illustrate the description of the great willow-tree in *The Fellowship of the Ring*, Book I, Chapter 6, *The Old Forest*: 'Enormous it looked, its sprawling branches going up like reaching arms with many long-fingered hands, its knotted and twisted trunk gaping in wide fissures that creaked faintly as the boughs moved.' It was published in *The J.R.R. Tolkien Calendar 1973* and subsequent calendars.

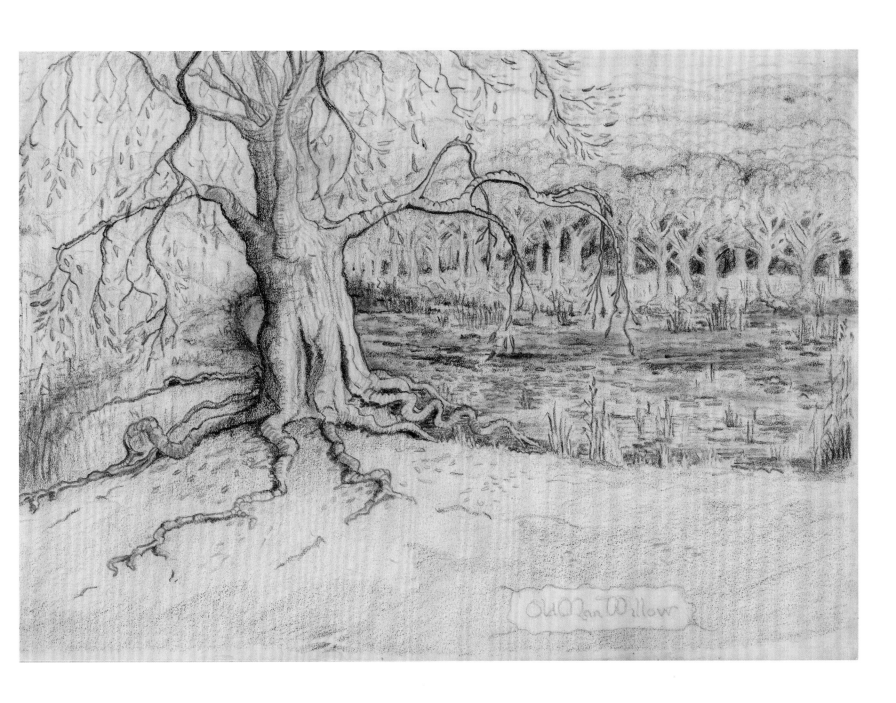

Old Man Willow

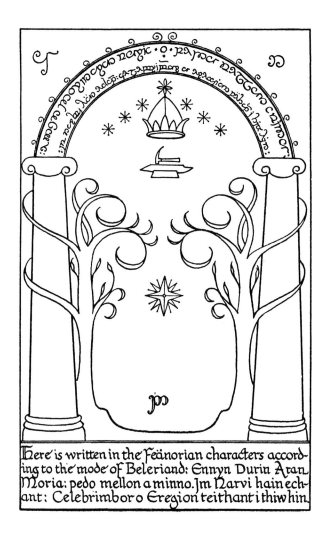

The drawing includes the following text:

Here is written in the Fëanorian characters according to the mode of Beleriand: Ennyn Durin Aran Moria: pedo mellon a minno. Im Narvi hain echant: Celebrimbor o Eregion teithant i thiw hin.

22. Doors of Durin and Moria Gate (I)

Crayon drawing of the West Gate of Moria, on the western side of the Misty Mountains, by which the Fellowship of the Ring entered the Mines: cf. *The Fellowship of the Ring*, Book II, Chapter 4, *A Journey in the Dark*: 'Beyond the ominous water were reared vast cliffs, their stern faces pallid in the fading light: final and impassable.' It was published in *The J.R.R. Tolkien Calendar 1973* and subsequent calendars. See further the note to no. 23.

The drawing of the Doors of Durin above is reproduced from the same chapter of *The Fellowship of the Ring*, where the words on the arch were thus translated by Gandalf: 'The Doors of Durin, Lord of Moria. Speak, friend, and enter. I, Narvi, made them. Celebrimbor of Hollin drew these signs.' It was only when Gandalf perceived that *pedo mellon a minno* should be translated 'Say "Friend" and enter', and uttered the word *Mellon*, that the Doors opened.

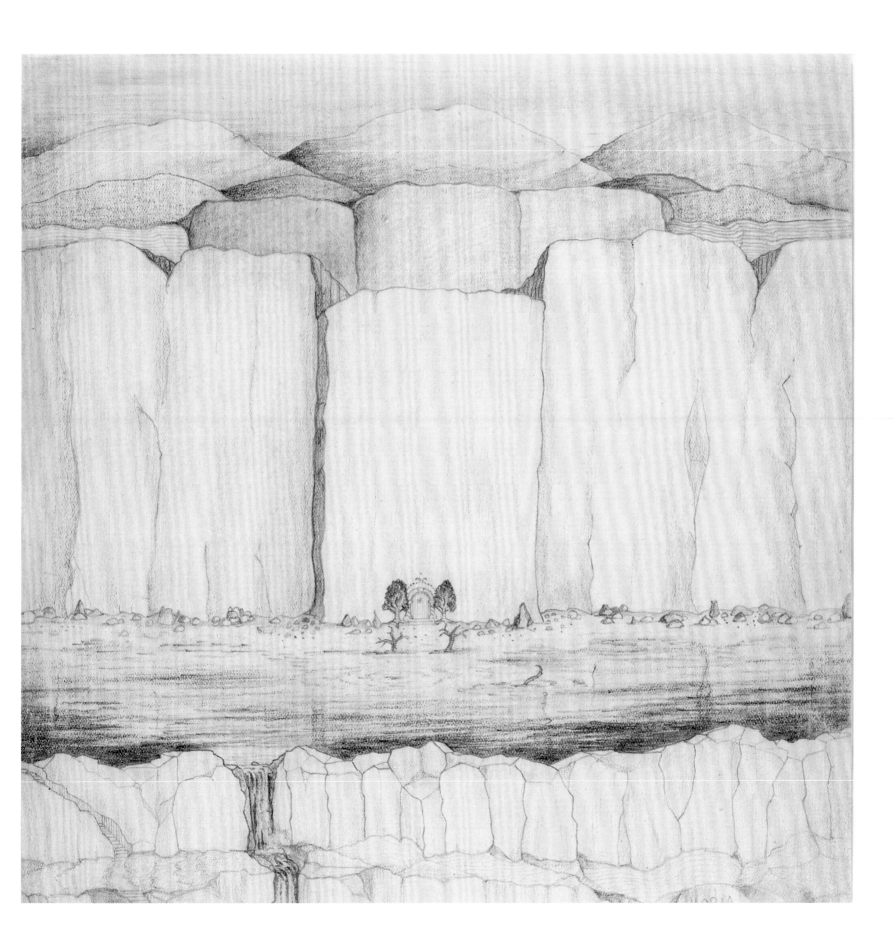

23. *Moria Gate (II)*

My description of this picture, published in *The J.R.R. Tolkien Calendar 1973*, in the original edition of this book ('the steps leading up to the Great Gates of Moria on the eastern side of the Misty Mountains') was entirely mistaken. In 1984 Mr Jeff Stevenson suggested that since no. 23 cannot be made to fit the description of the East Gate of Moria in *The Fellowship of the Ring*, and since the bottom of no. 22 closely matches the top of no. 23, no. 23 was in fact the original lower part of no. 22, which had been cut off. This was obviously correct without further evidence, but subsequently I found a letter from my father to Rayner Unwin, referring to the calendar in which the two illustrations appeared, in which he said: 'The picture for September [no. 23 in this book] seems to me rather poor: the bottom end of the following picture for October [no. 22 in this book] which was cut off and not meant to be used.' It may also be noted that the title 'Moria Gate' on no. 22 (which is slightly truncated at the bottom in the reproduction) was written in quite roughly when the true bottom, with an elegant title, was cut off. I do not know how it came about that the rejected strip from the bottom of the picture came to be used in the calendar, but the reason for cutting it off was surely that it did not agree with the text in the relations of the road, the stairs, and the stream (Sirannon). Yet even with the bottom strip removed the Stair Falls appear as a foaming torrent, whereas already in the original draft of the passage (*The Return of the Shadow*, 1988, p.446) there was only 'a trickling fall of water', which 'plainly… had once been much stronger.' It seems probable therefore that the picture preceded any written account of the approach to the West Gate of Moria.

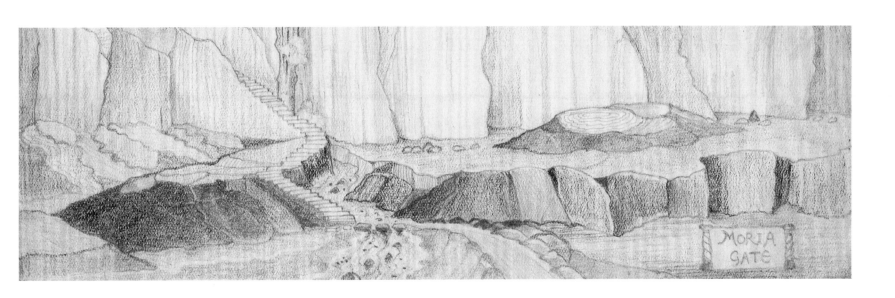

24. *Leaves from the Book of Mazarbul*

The Book of Mazarbul, found by the Fellowship of the Ring in the Chamber of Mazarbul in Moria, recorded the fortunes of the people of Balin the Dwarf. 'It had been slashed and stabbed and partly burned, and it was so stained with black and other dark marks like old blood that little of it could be read.' These facsimile pages were published in *The Lord of the Rings Calendar 1977*, accompanied by the following note on their interpretation:

I

This page of the Book of Mazarbul exemplifies the late form of the Angerthas, called 'the usage of Erebor'. This use would be expected in a kind of diary, written, hastily and without attempt at calligraphy or meticulous consistency of spelling, by Dwarves coming from Dale. Almost all the runes can be interpreted by reference to the section on the Cirth in Appendix E to *The Lord of the Rings*, where also the modifications of the Angerthas Moria made by the Dwarves of Erebor are briefly described.

The Book of Mazarbul was written in Westron, the Common Speech, which in the pages here reproduced is represented, as throughout *The Lord of the Rings*, by Modern English. In writing the Common Speech the Dwarves tended to blend its customary spelling with certain phonetic usages: for they did not like to use any letter or rune in more than one value, nor to express a simple sound by combinations of letters. In representation of this, it will be found that the spelling here is not on the basis of one runic sign for each Modern English letter; for example, the word *chamber* in line 13 is spelt with only five runes, there being a rune for *ch* and a rune for *mb*.

In the transcript that follows these features are not indicated. It may be noted that the word *the* is represented by a short vertical stroke; the word *of* by the rune for *v*; and (often) the word *is* by the rune for *z*. There are also single signs for *ai*, *ay*; *ea*; *ew*; *ou*, *ow*. The rune in the top right-hand corner is the numeral 3.

The passage in *The Lord of the Rings* in which Gandalf reads out these pages will be found in *The Fellowship of the Ring*, Book II, at the beginning of Ch. 5, *The Bridge of Khazad-dûm*. It is possible to make out a little more of the text than Gandalf was able to do in the Chamber of Mazarbul.

1 We drove out orcs from the great gate and guard
2 (r)oom and took the first hall: we slew many in the br
3 (i)ght sun in the dale: Flói was killed by an arr
4 ow. He slew the great chiefta(in)...........................Flói
5 under grass near Mirrormer(e)...........................came
6 ...ken
7 (w?)e repaire(d ...
8 ...
9 We have taken the twentyfirst hall of northen
10 nd to dwell in There is g(ood) air...............................
11 ...that can easily be
12 watched.......the shaft is clear
13 Balin has set up his seat in the chamber of Maz
14 arbul.......ga(th)ere...
15 Gold...
16 ...
17wonderful (lay?) Durin's Axesil
18 ver helm Balin h(a)s ta(k)en them for his own
19 Balin is now lord of Moria:

 * * * * * *

20today we found truesilver...........................
21wellforged hel(m
22 n..coat m(ade?) all of purest mithril...........................
23 Óin to seek for the upper armouries of the third deep
24go westwards to s...........................to Hollin gate

 * * * *

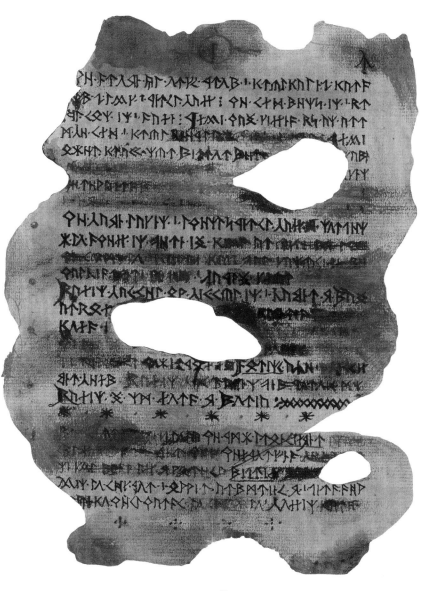

I

II

Gandalf paused and set a few leaves aside. 'There are several pages of the same sort, rather hastily written and much damaged,' he said; 'but I can make little of them in this light. Now there must be a number of leaves missing, because they begin to be numbered *five*, the fifth year of the colony, I suppose. Let me see! No, they are too cut and stained; I cannot read them. We might do better in the sunlight. Wait! Here is something: a large bold hand using an Elvish script.'

'That would be Ori's hand,' said Gimli, looking over the wizard's arm. 'He could write well and speedily, and often used the Elvish characters.'

'I fear he had ill tidings to record in a fair hand,' said Gandalf.

The Fellowship of the Ring, Book II, Ch. 5, *The Bridge of Khazad- dûm.*

This page is written in the later or Westron convention, in its northern variety, in the application of the Elvish signs to the Common Western Speech. The script can be interpreted from the information given in Appendix E to *The Lord of the Rings*; but the following points may be noted. The vowels are expressed not in *tehtar* but by separate letters, *a, e, o, u* being represented by the *tengwar* 24, 35, 23, 22 respectively (see the table in *The Lord of the Rings*, Appendix E), and *i* by an *i* undotted or with an acute stroke above. For *y*, as in *many* line 9, a *j* is used, and for *w* both *tengwar* 22 and 25; but the dipthongs *ou, ow* (as in *sorrow* line 3, *dou(b)t* line 13) and *ew* (as in *slew* line 9) are expressed by a curl over the first element, and *ay* (as in *day* line 4) by two dots over the *a*-letter.

e is often indicated (as in *alone* line 6, *Silverlode* line 10) by a dot placed under the preceding letter.

A bar over a consonant is used to show that it is preceded by a nasal, as in *went* line 6; and a double consonant may be expressed by a bar beneath the latter, as in *barred* line 13. For double *l tengwa* 28 is used.

The runic figure at the bottom of the page is the numeral 5.

1 r............... arz (probably for *ars*, the end of *years?*)
2 since.. ready
3 sorrow ..(y)ester
4 day being the tenth of november
5 Balin lord of Moria fell
6 in Dimrill Dale; he went alone
7 to look in Mirrormere. an orc
8 shot him from behind a stone. we
9 slew the orc but many more ca.............
10 p from east up the Silverlode...............
11 we rescued Balin's b(ody)
12 ...re a sharp battle
13 we have barred the gates but doubt if
14 can hold them long. if there is......
15 no escape it will be a horrible fate (to)
16 suffer – but I shall hold

III

The last page of the Book of Mazarbul. The runes employed are the same as those on the first of these facsimiles, though the hand is different and the shapes differ in detail. The last line is in the same Elvish alphabet as that used on the second page.

1 We cannot get out: we cannot get out
2 they have taken the bridge and second h
3 (a)ll. Frár & Lóni & Náli fell the
4 re bravely wh(ile the) rest retr.......................
5 Ma(zarb)ul. We still ho...................................
6 g: but hope u n............... (Ó?)ins p
7 arty went 5 days ago but (today) only
8 4 returned: the pool is up to the wall
9 at Westgate: the watcher in the water too
10 k Óin – we cannot get out: the end com
11 es soon we hear drums drums in the deep
They are coming

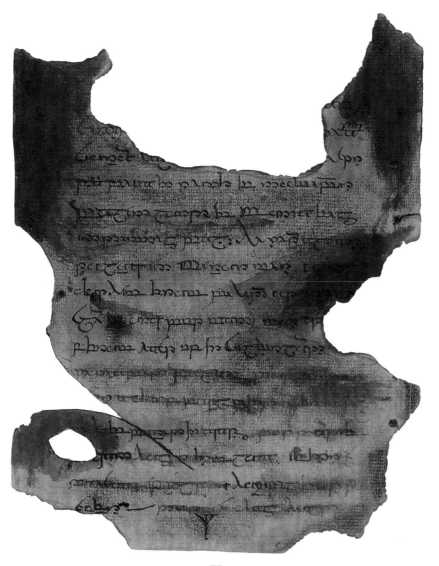

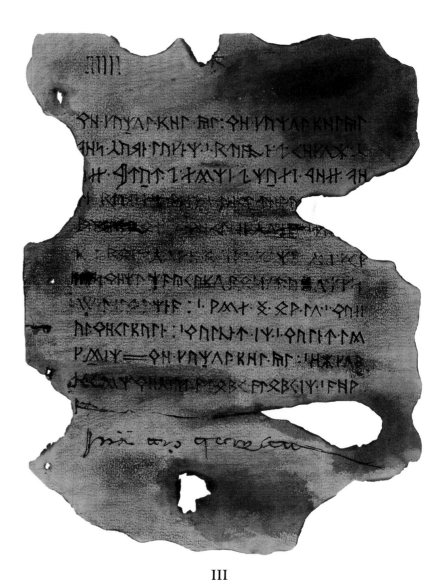

II

III

25. *The Forest of Lothlórien in Spring*

Crayon drawing of the mallorn trees of Lothlórien, published in *The J.R.R. Tolkien Calendar 1974*; cf. *The Fellowship of the Ring*, Book II, Chapter 6: 'There are no trees like the trees of that land. For in the autumn their leaves fall not, but turn to gold. Not till the spring comes and the new green opens do they fall, and then the boughs are laden with yellow flowers; and the floor of the wood is golden, and golden is the roof, and its pillars are of silver, for the bark of the trees is smooth and grey.'

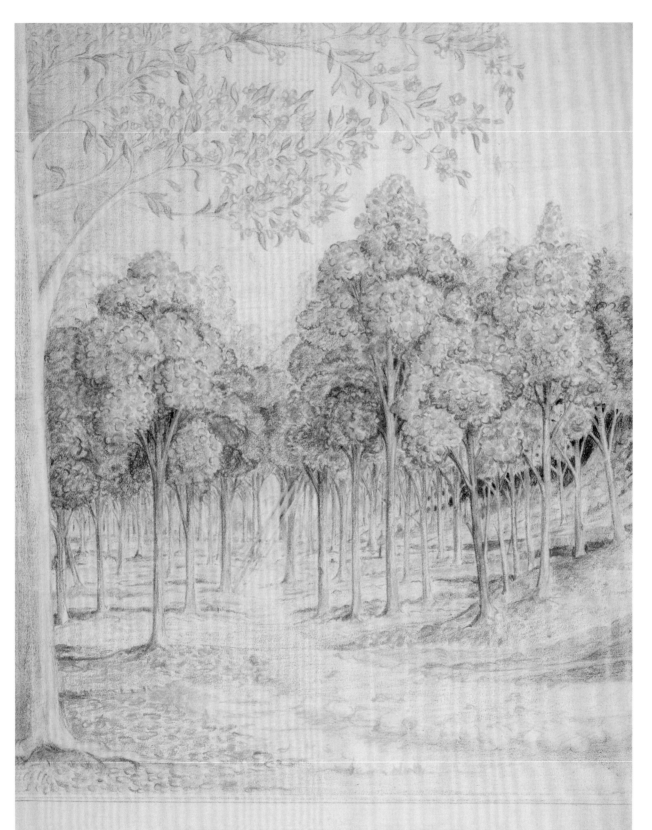

The Forest of Lothlorien in Spring

26. *Helm's Deep and the Hornburg*

This sketch was done on a page from an examination script, and partly over the handwriting itself; in the reproduction (published in *The Lord of the Rings Calendar 1977*) the writing has been removed. A description is given in *The Two Towers*, Book III, Chapter 7, of the Hornburg on the Hornrock, the gorge of Helm's Deep, and the Deeping Stream.

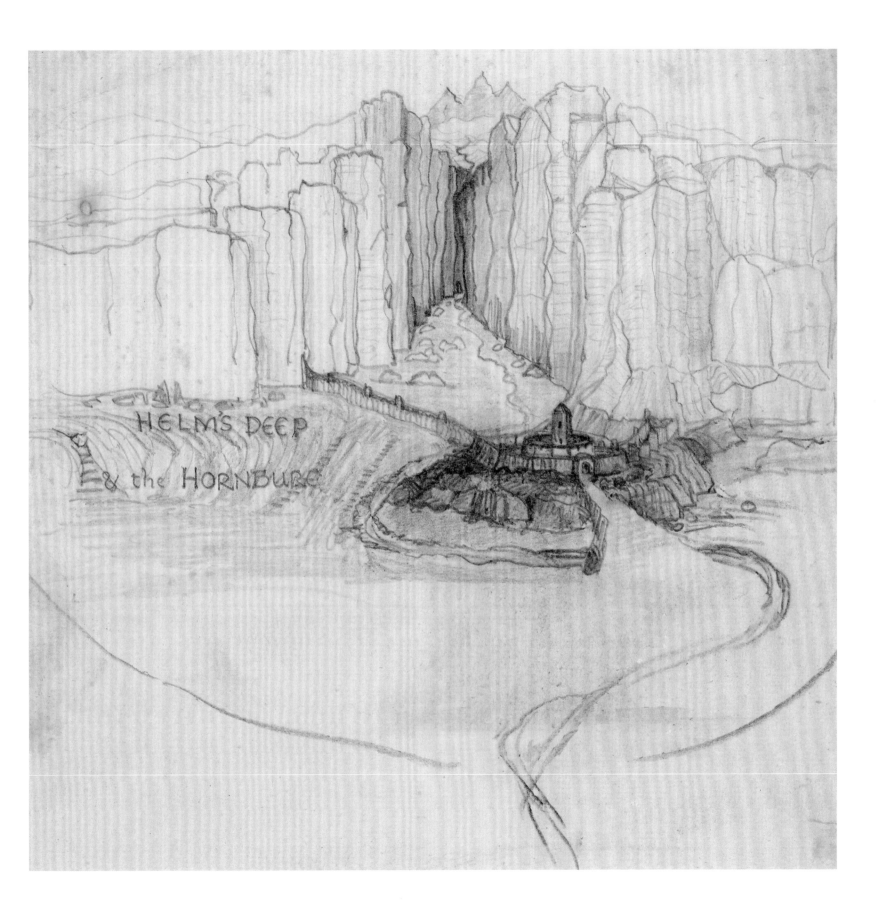

HELM'S DEEP

& the HORNBURG

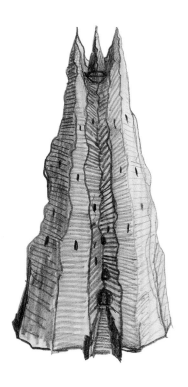

27. *Orthanc* and *Minas Tirith*

These two pictures were published together in *The Lord of the Rings Calendar 1977*. This is the final conception of Orthanc, the tower of Isengard; cf. *The Two Towers*, Book III, Chapter 8, *The Road to Isengard*: 'A peak and isle of rock it was, black and gleaming hard: four mighty piers of many-sided stone were welded into one, but near the summit they opened into gaping horns, their pinnacles sharp as the points of spears, keen-edged as knives.' An account with illustrations of my father's changing ideas of the structure of Orthanc is given in *The War of the Ring*, 1990, pp.31–5.

The unfinished picture of Minas Tirith is entitled *Stanburg* and *Steinborg* (only the latter visible in the reproduction), these being the Old English and Old Norse forms of a name meaning 'Stone-fortress, Stone-city'. In the original edition of this book I interpreted the word in Elvish letters as *Stanburg*, but Mr Arden R. Smith has shown that it reads in fact *Steinborg*.

Steinborg

Gòmpronty

28. *Shelob's Lair*

This sketch, published in *The Lord of the Rings Calendar 1977*, is found on a page of an early draft of the story in *The Two Towers* of the ascent to the Tower of Cirith Ungol. At that stage the story, and the topography, differed radically from the final form, in that the Spider's Lair in the tunnel lay between the First Stair and the Second Stair, not as afterwards beyond the Second Stair. The page of the text surrounding the sketch takes up from the point where Gollum, having passed through the tunnel with Frodo and Sam and reached the top of the Second Stair, suddenly fled into darkness. The development of the story is described in *The War of the Ring*, 1990, Part Two, Chapter VIII, where the manuscript page reproduced here is printed (pp.195–6). At this stage the Spider was Ungoliant; the caption 'Shelob's Lair' was pencilled in later.

'That's that!' said Sam. What we expected. But I don't like it. I suppose we've come just exactly where he wanted to bring us. Well, let's get moving away as quick as we can. That was the acher as worn't. That's last whistle if this wasn't pure joy at getting out of the tunnel. It was pure wickedness from start. And what next we'll soon know.

Likely enough, said Frodo. But we couldn't have got even so far without him. Do you ever manage our errand, then Gollum and all his wickedness will be part of the plan.

So far you say, said Sam. This far? Where are we now?

About at the crest of the main range of the Ephel dúath I guess, said Frodo. Look! the road goes level now, it then went on up, but no longer steeply. Beyond and ahead there was an ominous glare in the sky, and like a great notch in the mountain wall a cleft was outlined against it. So ...

On their right the wall of rock fell away and beyond darkness of ... the head of Morghul dale. ...

On their left sharp jagged pinnacles stood up like towers carved by the ... years, and between them were deep dark ...

... I don't like the look of that, said Sam. This upper pass is guarded too. D'you remember he never would say if the road or no. D'you think he's gone to fetch them — orcs or something?

No, I don't think so, said Frodo. ... to no good, of course, but I don't think that he's gone to fetch orcs. ...

... the whole time it has been the way for poor Smeagol, ... been his scheme. But how coming up here will help him, I can't guess.

He was soon to learn.

Frodo went forward now — the last lap — and he exerted all his strength. He felt that if once he could get to the saddle of the pass and look over into the Nameless Land he could have accomplished something. Sam followed. He sensed evil all round him. He knew that they had walked into some trap, but what? He had sheathed his sword, but now he drew it in readiness. He halted for a moment, and stooped to pick up his staff with his left hand

CYCLOPS WALL

29. *Dunharrow*

The original of this picture in crayon, published in *The Lord of the Rings Calendar 1977*, bears a note on the back: 'No longer fits story'. It was made at an early stage in the development of the conception of Dunharrow, which is described thus in an early draft: 'At last they came to a sharp brink and the road passed between walls of rock and led them out onto a wide upland: the Lap of Starkhorn men called it, a green mountain-field of grass and heath above the sheer wall of the valley that stretched back to the feet of a high northern buttress of the mountain. When it reached this at one place it entered in, forming a great recess, clasped by walls of rock that rose at the back to a lofty precipice. More than a half-circle this was in shape, its entrance a narrow gap between sharp pinnacles of rock that opened to the west. Two long lines of unshaped stones marched from the brink of the cliff towards it, and in the middle of its rock-ringed floor under the shadow of the mountain one tall menhir stood alone. At the back under the eastern precipice a huge door opened, carved with signs and figures worn by time that none could read. Many other lesser doors there were at either side, and peeping holes far up in the surrounding walls. This was the Hold of Dunharrow, the work of long-forgotten men. No song or legend remembered them, and their name was lost. For what purpose they had made this place, a town, or secret temple, or a tomb of hidden kings, no one could say.'

Thus the actual Hold of Dunharrow as then conceived, a great natural amphitheatre with cavernous halls in the cliff at its rear, is invisible in this picture. The early history of Dunharrow is described in *The War of the Ring*, 1990, pp.235–51.

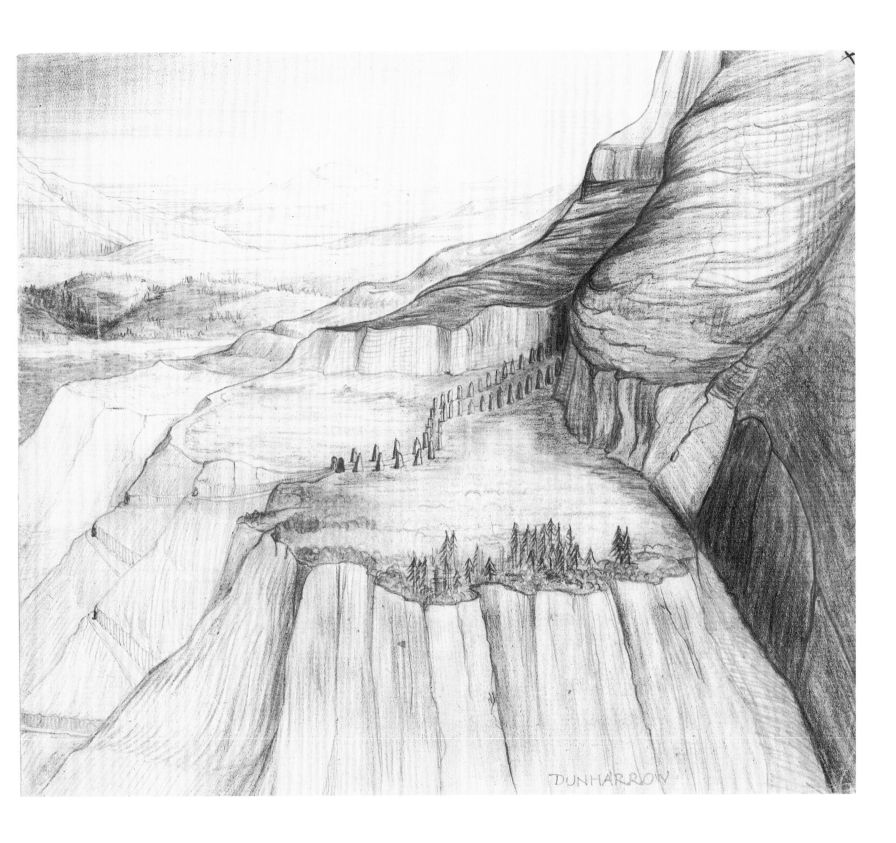

DUNHARROW

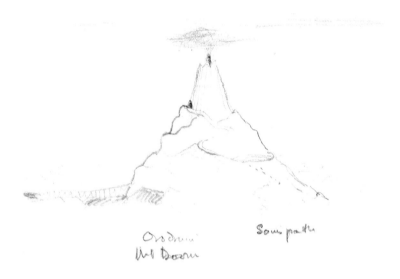

Orodruin
Mt Doom Sauron's path

30. *Orodruin and Barad-dûr*

This sketch of Orodruin (Mount Doom), published in *The Lord of the Rings Calendar 1977*, was done on a small page carrying drafting for the chapter *Mount Doom* in *The Return of the King*. In the original the tongue of flame from the cone of the volcano is coloured red, and beneath the words visible in the reproduction is written 'Mt Doom from the North'. In this sketch is seen the 'long sloping causeway that led up to the Mountain's eastern side', carrying Sauron's Road from Barad-dûr up to the dark entrance of the Sammath Naur, the Chambers of Fire. In all versions of the text the climbing road came 'high in the upper cone, but still far from the reeking summit, to a dark entrance'. In the sketch the entrance seems to be at the base of the cone, but in the original drawing it can be seen that the mountain-slope on the eastern side below the entrance is marked with vertical lines, showing it to be a part of the cone.

The painting of the Dark Tower, published in *The J.R.R. Tolkien Calendar 1973* and subsequent calendars, shows a door on the eastern side of the fortress with Mount Doom to the westward.

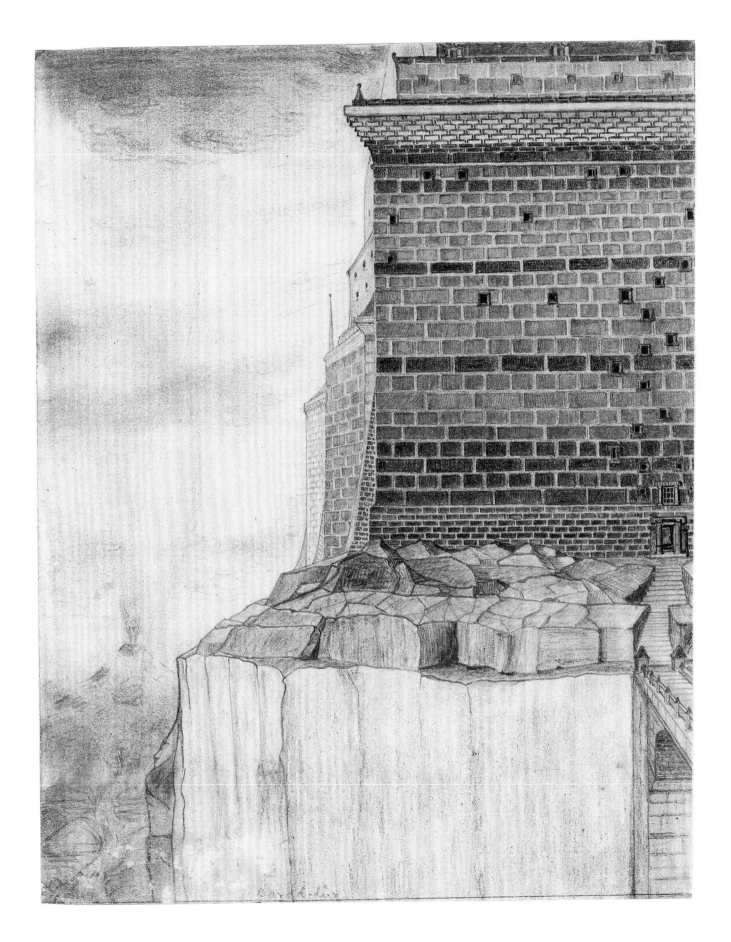

31. *Taniquetil*

This watercolour dates in all probability from the same period (1927–8) as the other *Silmarillion* paintings. It was published in *The J.R.R. Tolkien Calendar 1974*, and again in *The Silmarillion Calendar 1978*. Taniquetil, called also Oiolossë, Amon Uilos, and Mount Everwhite, was the highest of the mountains that guarded Valinor and the highest mountain of Arda, 'upon whose summit Manwë set his throne'. In the foreground is one of the white swan-ships of the Telerin Elves who dwelt on the coast of Aman.

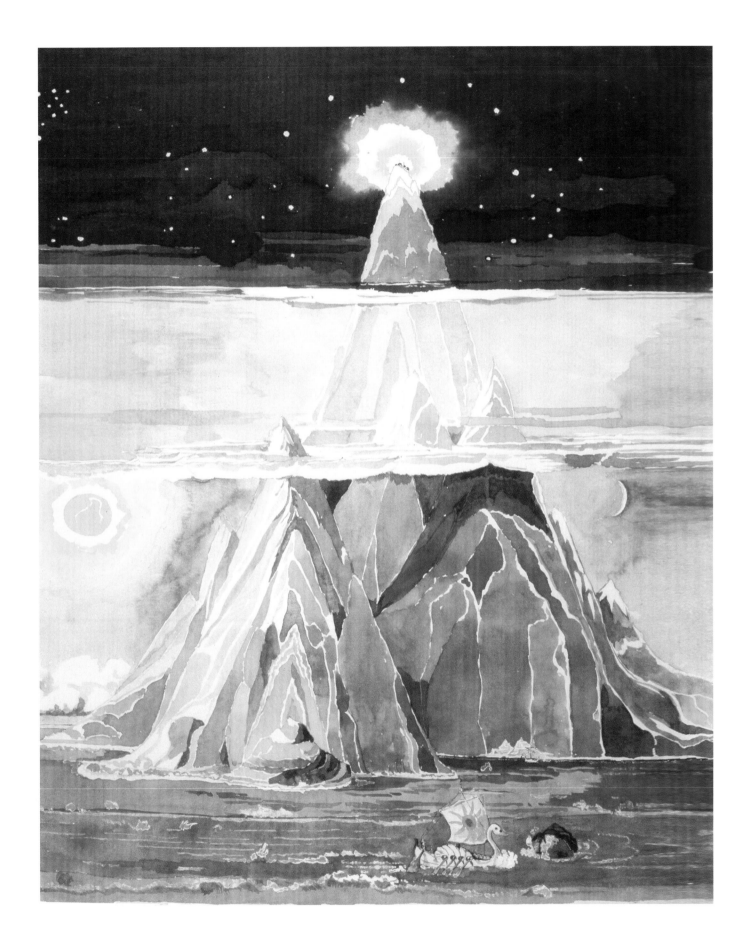

32. *Lake Mithrim*

This watercolour, dated 1927, was published in *The Silmarillion Calendar 1978*, together with the heraldic devices of Fëanor, Fingolfin, Hador, and Eärendil, who were associated with the region (Eärendil through his father Tuor). In this book these devices have been grouped with others that appeared in the same calendar (see no. 47). Lake Mithrim lay in the east of Hithlum; about its shores the divided hosts of the Noldorin Elves made their encampments after their return to Middle-earth (*The Silmarillion*, Chapter 13, *Of the Return of the Noldor*).

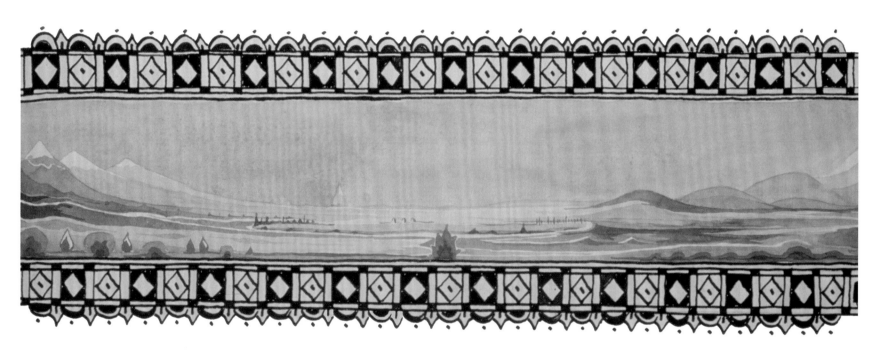

33. *Nargothrond (I)*

This unfinished watercolour of the triple entrances to the great underground fortress of Finrod Felagund, published in *The Silmarillion Calendar 1978*, was no doubt painted during the same period as the drawing of Nargothrond (see no. 34). My father used a closely similar conception in one of his drawings of the Gate of the Elvenking's Hall, with the lie of the land and the form of the hills almost identical in both, but with a single entrance in the latter picture: this is reproduced in the anniversary edition of *The Hobbit*, 1987, p.viii.

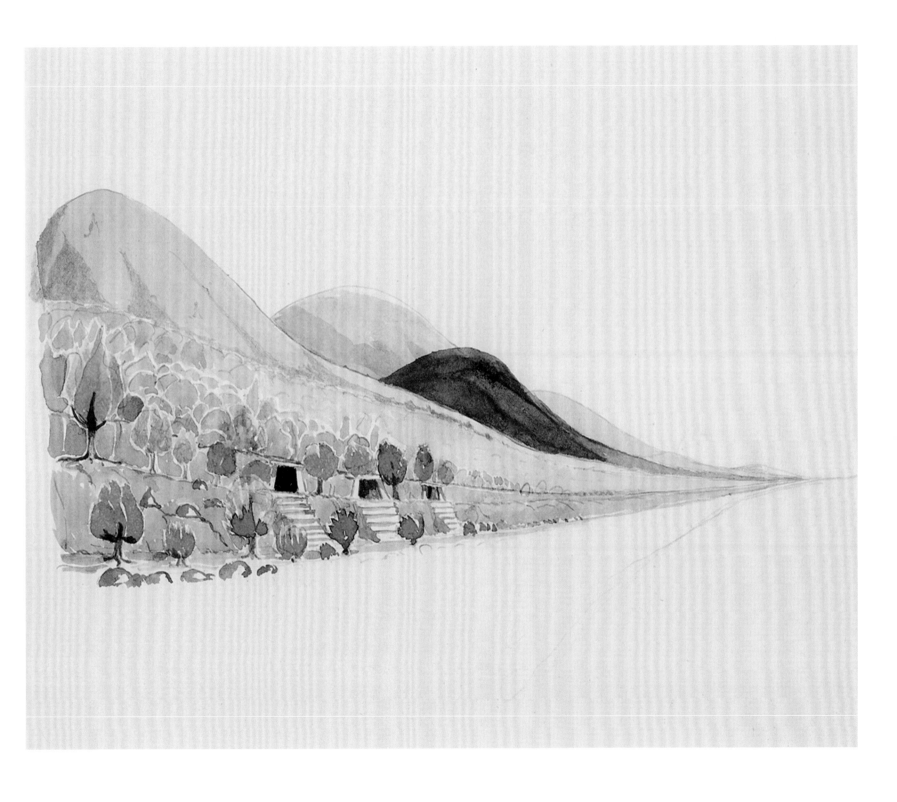

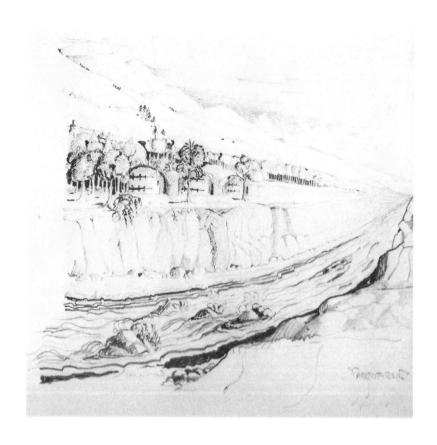

34. *Nargothrond (II)*

This drawing of Nargothrond, showing a different conception of the doors from that in the watercolour (no. 33), has not been previously published in its original form, but the coloured version by H.E. Riddett appeared in *The Silmarillion Calendar 1978*. The original was done at Lyme Regis in Dorset in 1928. This entrance to Nargothrond is shown as it was before the great bridge of Túrin was built over the River Narog (*The Silmarillion*, Chapter 21, *Of Túrin Turambar*).

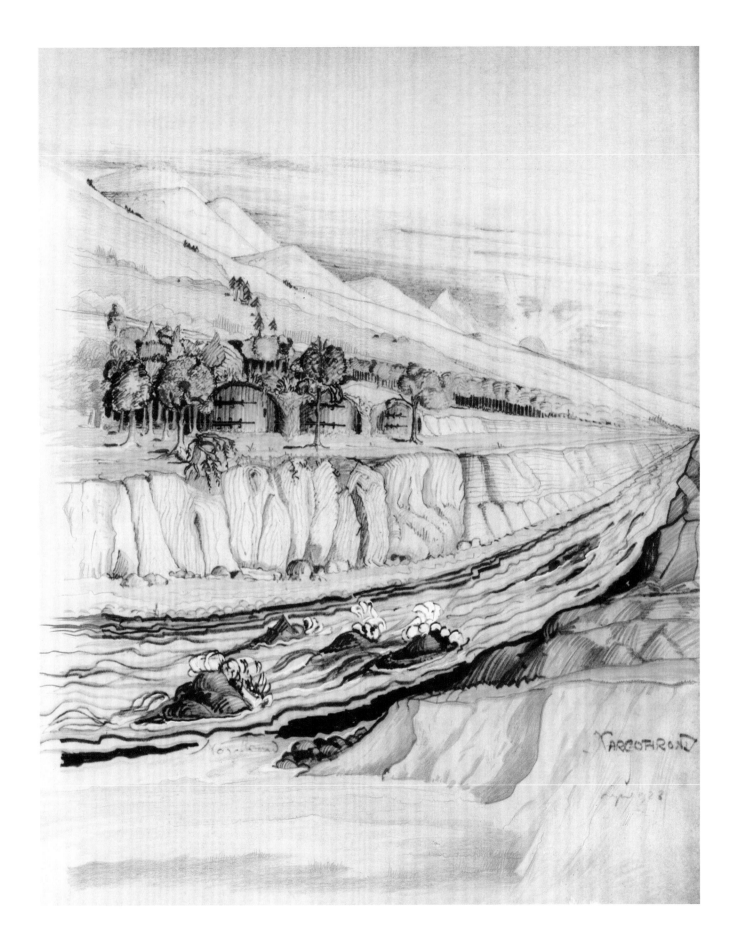

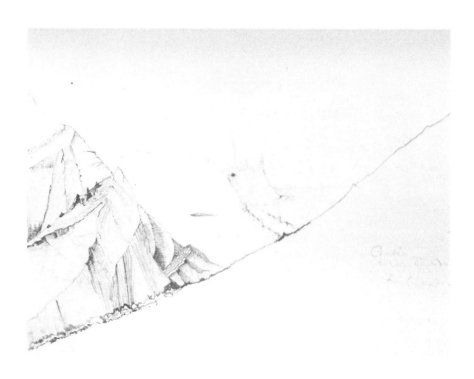

35. *Gondolin and the Vale of Tumladen*

This drawing, dated September 1928, has not been previously published in its original form, but the coloured version by H.E. Riddett appeared in *The Silmarillion Calendar 1978*. The name Cristhorn, seen in the pencilled title 'Gondolin & the Vale of Tumladin from Cristhorn', means 'The Eagles Cleft'; it was afterwards changed to 'Cirith Thoronath', of the same meaning. Here Glorfindel fought with the Balrog who ambushed those who fled from the sack of the city (*The Silmarillion*, Chapter 23, *Of Tuor and the Fall of Gondolin*).

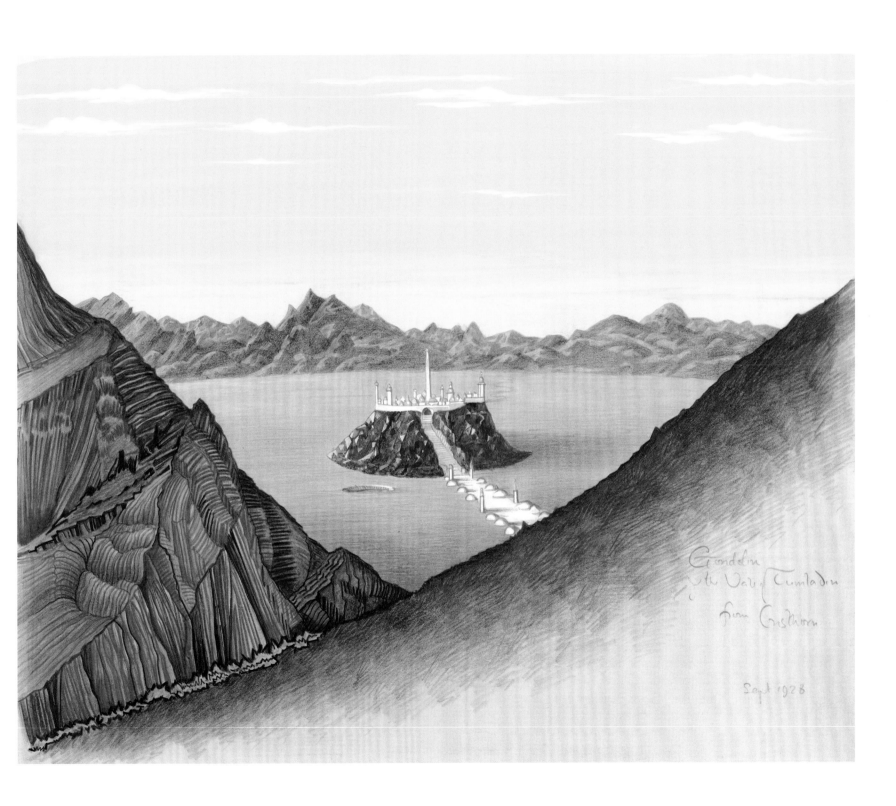

Gondolin
the Vale of Tumladen
from Cristhorn

Sept 1928

36. *Tol Sirion*

This drawing has not been previously published in its original form, but the coloured version by H.E. Riddett appeared in *The Silmarillion Calendar 1978*. The original, like no. 34, was done at Lyme Regis in Dorset in 1928.

The picture shows Minas Tirith, the watchtower of Finrod Felagund, on the island of Tol Sirion, which after its capture by Sauron was named Tol-in-Gaurhoth, the Isle of Werewolves. To the left are Ered Wethrin, the Mountains of Shadow, and to the right the western edge of Dorthonion (Taur-nu-Fuin); beyond lies the wide plain of Ard-galen, called after its devastation Anfauglith, and on the far northern horizon is the line of Ered Engrin, the Iron Mountains, with smoke hanging over Thangorodrim. In the original drawing the far horizon appears less remote and the multiple peaks of Thangorodrim are seen.

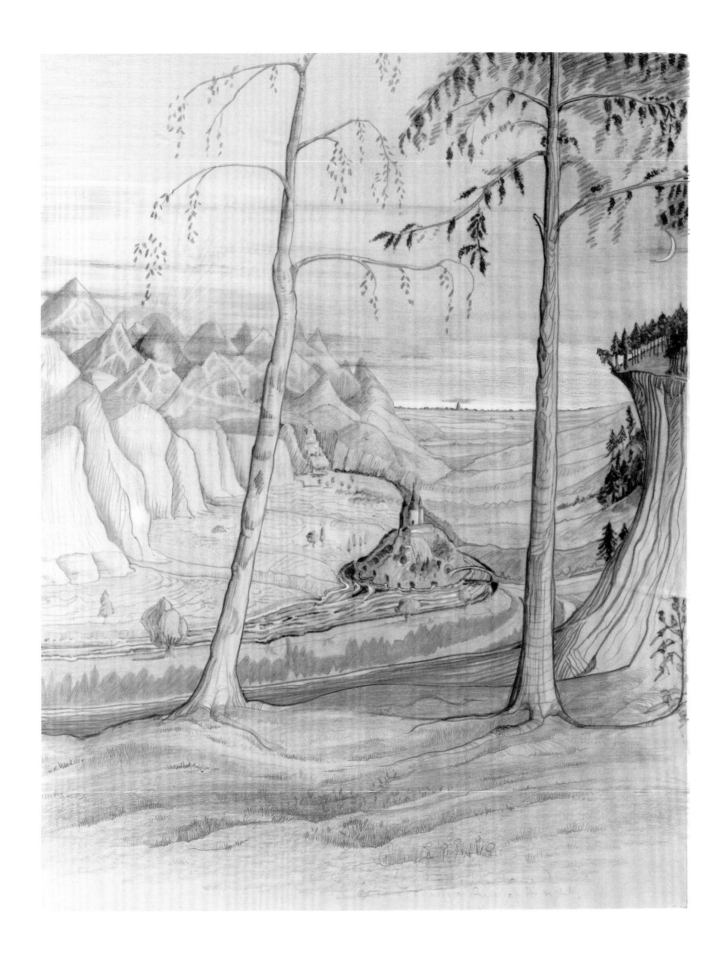

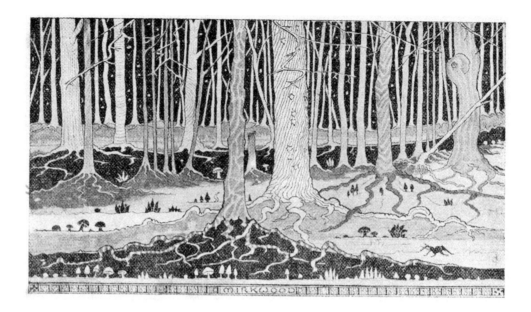

37. *Mirkwood* and *Beleg finds Gwindor in Taur-nu-Fuin* (entitled *Fangorn Forest*)

The black and white picture of Mirkwood was published in the first impression of *The Hobbit*, 1937 (in Chapter 8, *Flies and Spiders*, though intended to be the endpaper); the original was given by my father to a friend and cannot now be traced.

The painting on the opposite page appeared first in *The J.R.R. Tolkien Calendar 1974*, and an enlargement of the central area of the picture in *The Lord of the Rings Calendar 1977*, in both calendars captioned 'Fangorn Forest', as in the inscription, in the hand of the artist, on the painting itself. In *The Silmarillion Calendar 1978* the same reproduction as in 1977 was used, but this time captioned 'Beleg finds Gwindor in Taur-nu-Fuin'. The reason for this is that while preparing the 1978 calendar I realised the original significance of the painting.

My father stated in a letter of 1937 that the picture of Mirkwood for *The Hobbit* was itself redrawn from a painting made earlier to illustrate the passage in *The Silmarillion* (Chapter 21) where Beleg finds Gwindor in the forest of Taur-nu-Fuin. That painting is beyond question the one reproduced here, despite the title 'Fangorn Forest'. In view of the title the two figures would naturally be taken to be the hobbits Pippin and Merry, straying in Fangorn before their encounter with Treebeard (*The Two Towers*, Book III, Chapter 4). It is clear, however, that this is not so; the figures are Elves and not hobbits; and the Elf climbing over the tree-roots is Beleg Strongbow of Doriath, bearing his great sword Anglachel (which was afterwards reforged for Túrin and from which he became known as the Black Sword of Nagothrond). The other is Gwindor of Nargothrond, lying exhausted after his escape from the mines of Angband, with his lamp beside him.

The only possible explanation is that my father decided that the *Silmarillion* painting could nevertheless be used, in the 1974 calendar, as an illustration of the hobbits in Fangorn Forest. It was probably done at the same time as the other *Silmarillion* paintings in the late 1920s.

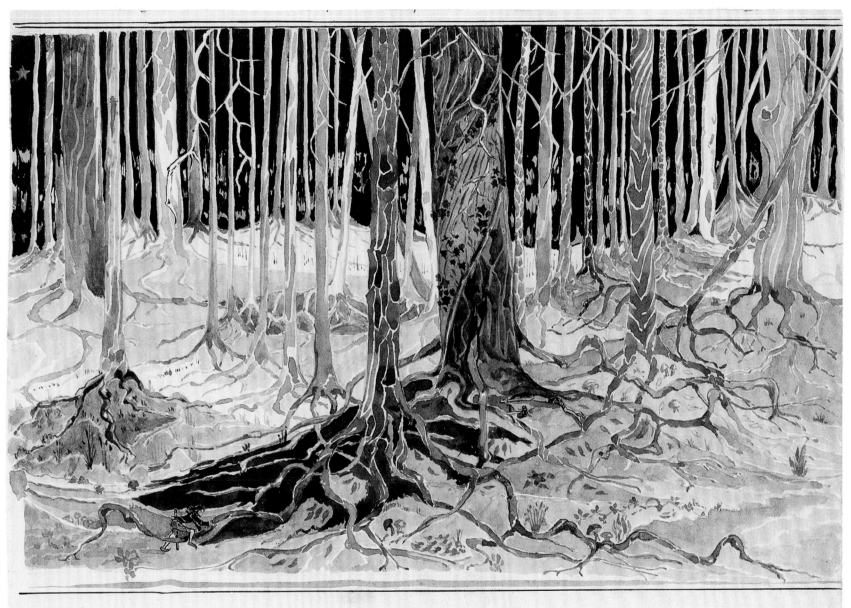

FANGORN FOREST

38. *Glaurung sets forth to seek Túrin*

This painting, dated 1927, was published in *The Silmarillion Calendar 1978*. The title is in Old English letters, which my father frequently used when writing in a formal style. At the time of the painting the name of the Father of Dragons was Glórund, not Glaurung, and for the reproduction in the calendar I rewrote the Old English lettering in precisely similar form in order to introduce the name by which the Dragon is known in the published work. The entrance to Nargothrond is here seen as a single arch, unlike the triple doors seen in nos. 33 and 34.

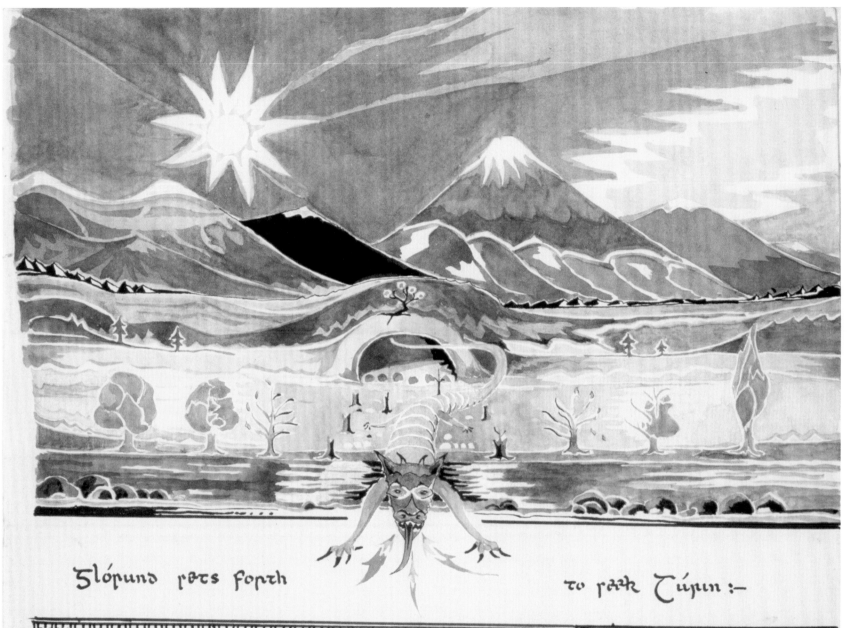

Glórund gœs forth to seek Túrin :—

39. *Polar Bear had fallen from top to bottom on his nose*

Published in *The Father Christmas Letters*, 1976, this painting of the interior of Cliff House at the North Pole, together with a letter describing the event, arrived at Christmas 1928, and thus belongs to the prolific period of painting from which derive the illustrations to *The Silmarillion* in this book.

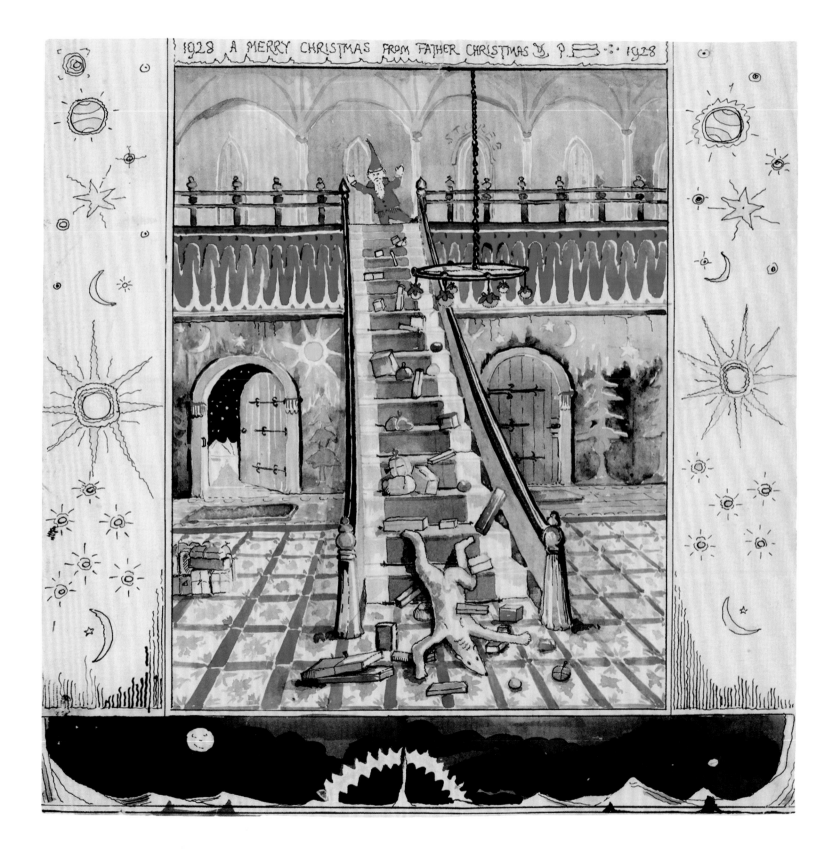

40. *Three Dragons*

These paintings date from the same period (1927–8) as the paintings and drawings illustrating *The Silmarillion*. Beneath the coiled dragon at the top appear in the original some words from the Old English poem *Beowulf* (line 2561): *hringbogan heorte gefysed*, rendered in my father's translation of the poem 'The heart of the coiling beast was stirred'. The three dragons were published in *The J.R.R. Tolkien Calendar 1979*, but the uppermost (in colour) and the warrior contending with a dragon (uncoloured) were used to illustrate the catalogue of the exhibition at the Ashmolean Museum, Oxford, and the National Book League, London, in 1976–7, and the former, as an embossed design in red, silver, and gold, appears on the cover of the De Luxe edition of *The Hobbit* (1976).

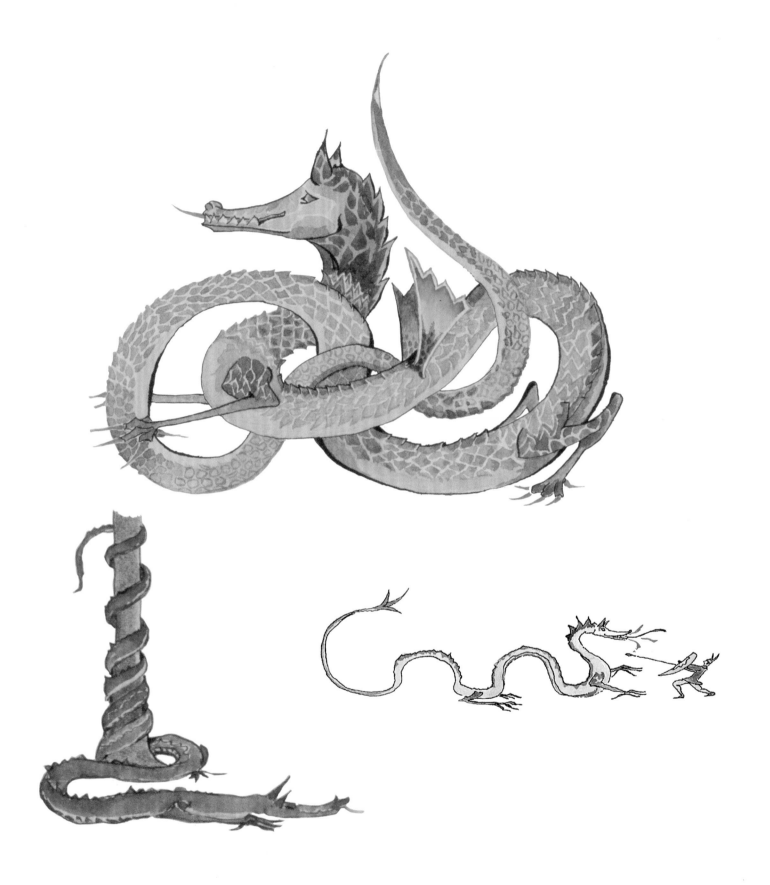

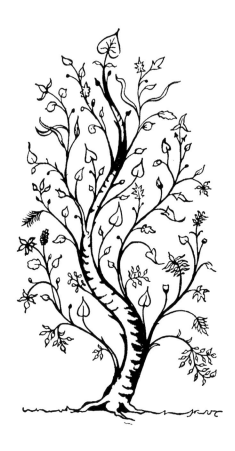

41. Trees

The upper tree on the left bears in the original the title 'The Tree of Amalion', as also does the tree done in crayon on grey paper below it. In these pictures the placing of the flowers and most of the flowers themselves are obviously similar and related; but I believe the lower tree to be much later than the upper, which dates from 1927–8.

Reproduced above is a third drawing of such a tree, bearing leaves (not flowers) of many different forms, which was done by my father as a cover design for the paperback edition of *Tree and Leaf* published in 1964; and while I cannot cast any light on the name *Amalion* itself, it is noteworthy that an earlier version of this design was entitled 'The Tree of Amalion. First draft for the cover of *Tree and Leaf*.'

This page of trees was published in *The J.R.R. Tolkien Calendar 1979*.

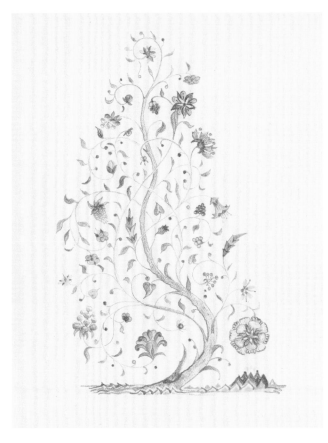

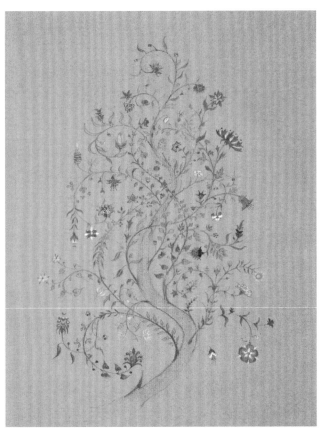

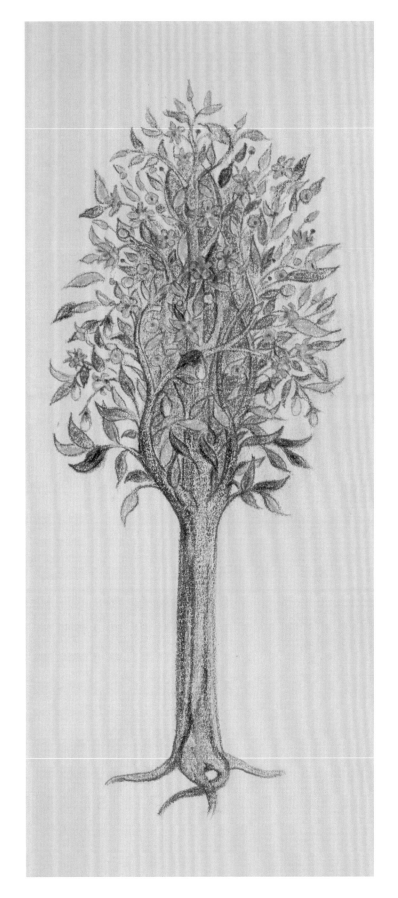

42. *Flowering Tree with Friezes*

This page, published in *The J.R.R. Tolkien Calendar 1979*, is made up (with the exception of the two flowers to right and left, which belong with those in no. 45) of much earlier compositions (late 1920s) than the designs reproduced in nos. 43–46. For the flowering tree see note to no. 41.

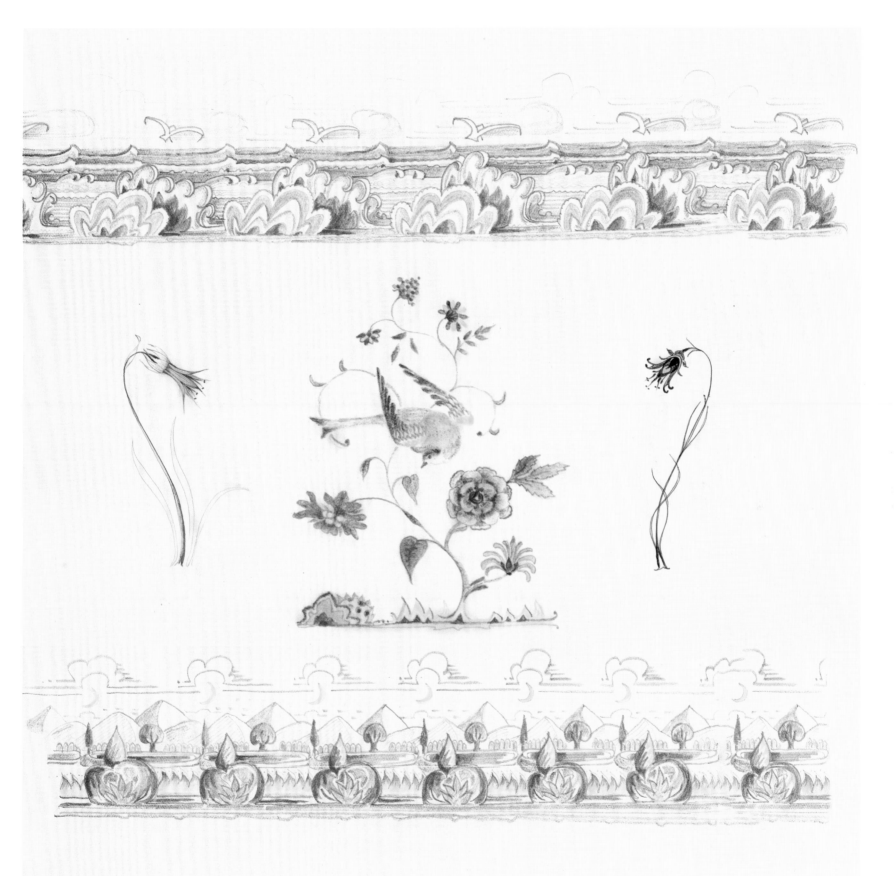

43. Patterns (I)

While doing newspaper crossword puzzles my father used to draw patterns such as those, selected from among many, that are reproduced here, previously published in *The J.R.R. Tolkien Calendar 1979*. They date from the 1960s, and are done with coloured ball-point pens. These designs were very frequently of flowers or flowerlike forms; others were friezes, or suggested heraldic devices, belts, or tapestries, and might then be associated with Númenórean works of art or flowers of the imagined world. See nos. 44–46, and also the Heraldic Devices, no. 47.

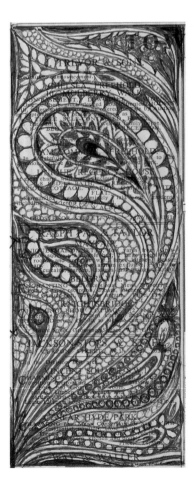

44. Patterns (II)

These designs, like those shown in no. 43, date from the 1960s, and were arranged thus for *The J.R.R. Tolkien Calendar 1979*.

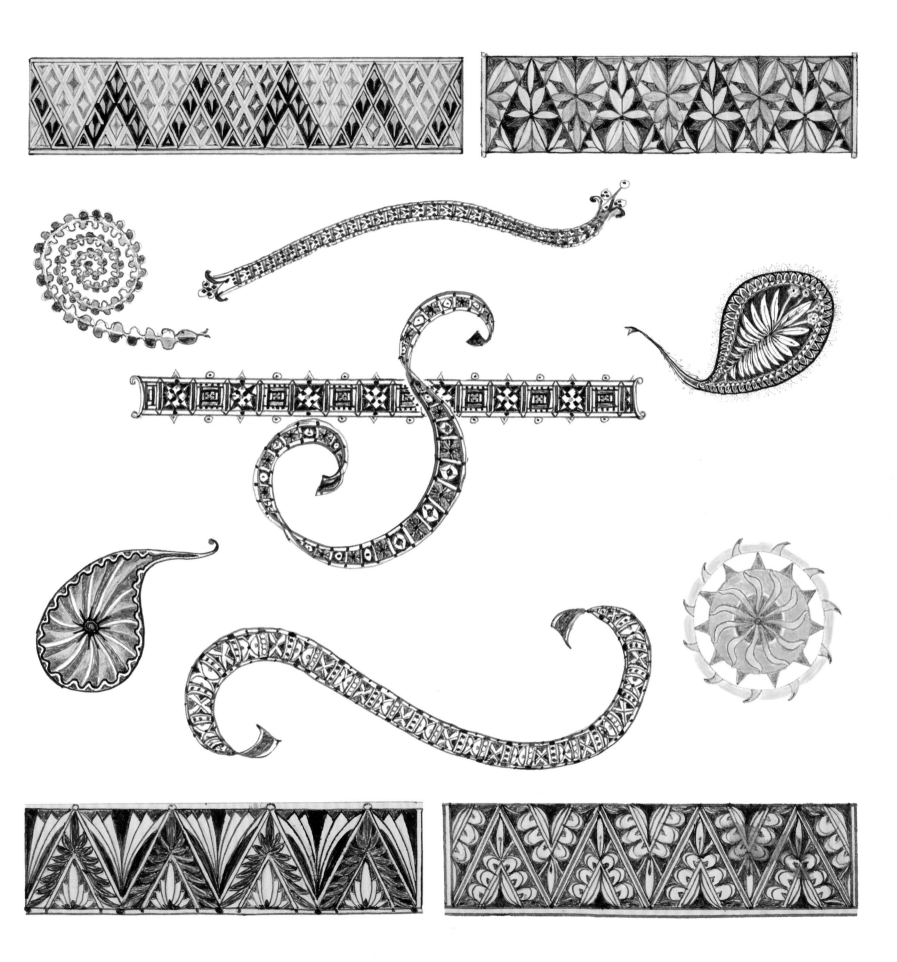

45. *Floral Designs*

See the note to no. 43. These are late designs, like those in nos. 43 and 44, and like them were published in *The J.R.R. Tolkien Calendar 1979* in this arrangement. The name *pilinehtar* belongs with the plant in the centre, which is one of many similar designs in black ink of slender rushlike or grasslike plants, several of them bearing Elvish names.

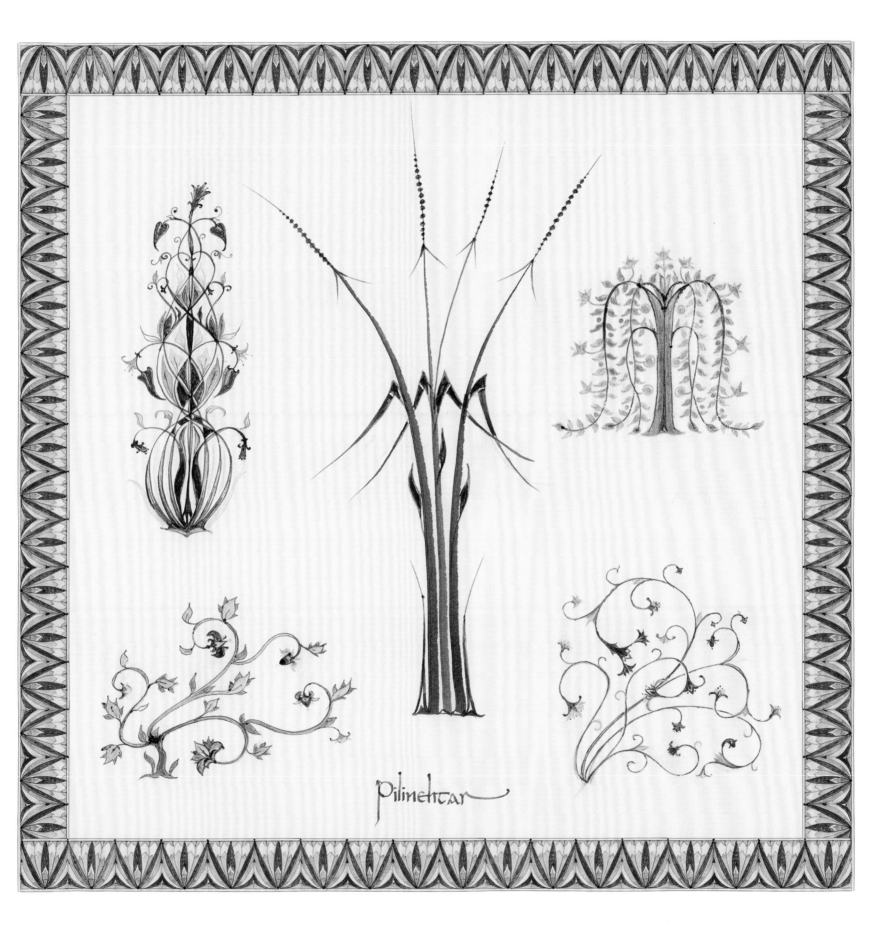

Pilinehtar

46. *Númenórean Tile and Textiles*

See the note to no. 43. Such artefacts would have been among the precious things saved from the Drowning of Númenor in the ships of Elendil and his sons Isildur and Anárion and brought to Middle-earth, as told in the *Akallabêth* (*The Silmarillion*, p. 276). The Númenórean tile was used as the centrepiece on the back of the cover of *The J.R.R. Tolkien Calendar 1974*, and both tile and textiles as reproduced here appeared in *The Silmarillion Calendar 1978*.

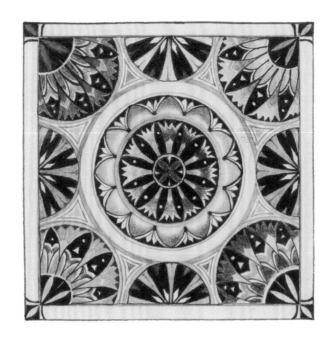

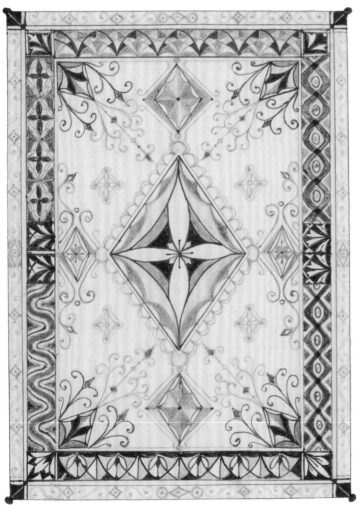

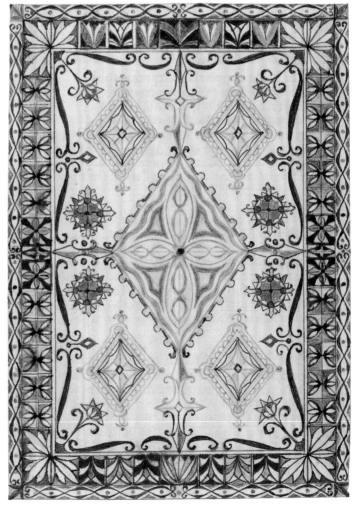

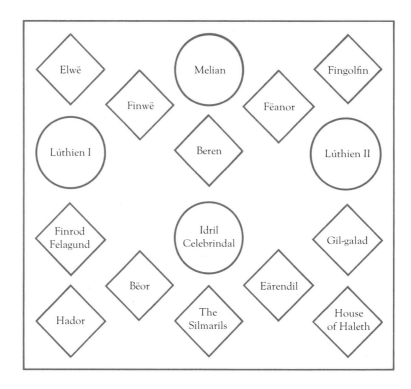

47. *Heraldic Devices*

See the note to no. 43. Eight of these devices were used on the back of the cover of *The J.R.R. Tolkien Calendar 1974* (those of Finwë and Eärendil in slightly different forms), and all the sixteen here reproduced appeared in *The Silmarillion Calendar 1978*, where the following note was given:

Some details of the emblems cannot now be explained, but the following notes draw attention to notable features. The device of Finwë, first king of the Noldorin Elves, is a winged sun, as that of Elwë (King Thingol of Doriath) is a winged moon with stars. Those of Finwë's sons Fëanor and Fingolfin are clearly related to Finwë's emblem, although in the case of Fëanor it is natural to associate the flames with the meaning of his name, *Feanáro* 'Spirit of Fire'. Gil-galad's device of white stars is also associated with his name, which means 'Star of Radiance'; but the harp of Finrod Felagund probably derives from the legend (*The Silmarillion*, Chapter 17) of his coming upon the first Men to enter Beleriand, and of his singing to them to the accompaniment of a harp that he found in their camp.

The white flowers that appear in the devices of Lúthien are probably to be connected with the flowers of *niphredil* that sprang at her birth in Doriath, as is told in *The Silmarillion*, Chapter 10. The emblem of Idril Celebrindal (daughter of Turgon of Gondolin and mother of Eärendil) is a cornflower pattern, and was named *Menelluin* ('Sky-blue'); this is stated to be an inlaid plaque saved from Gondolin and descending through Eärendil and his sons Elros to Númenor, whence it was saved by Elendil and taken to Gondor. Its influence on Númenórean circular designs can be seen in the Númenórean tile (no. 46).

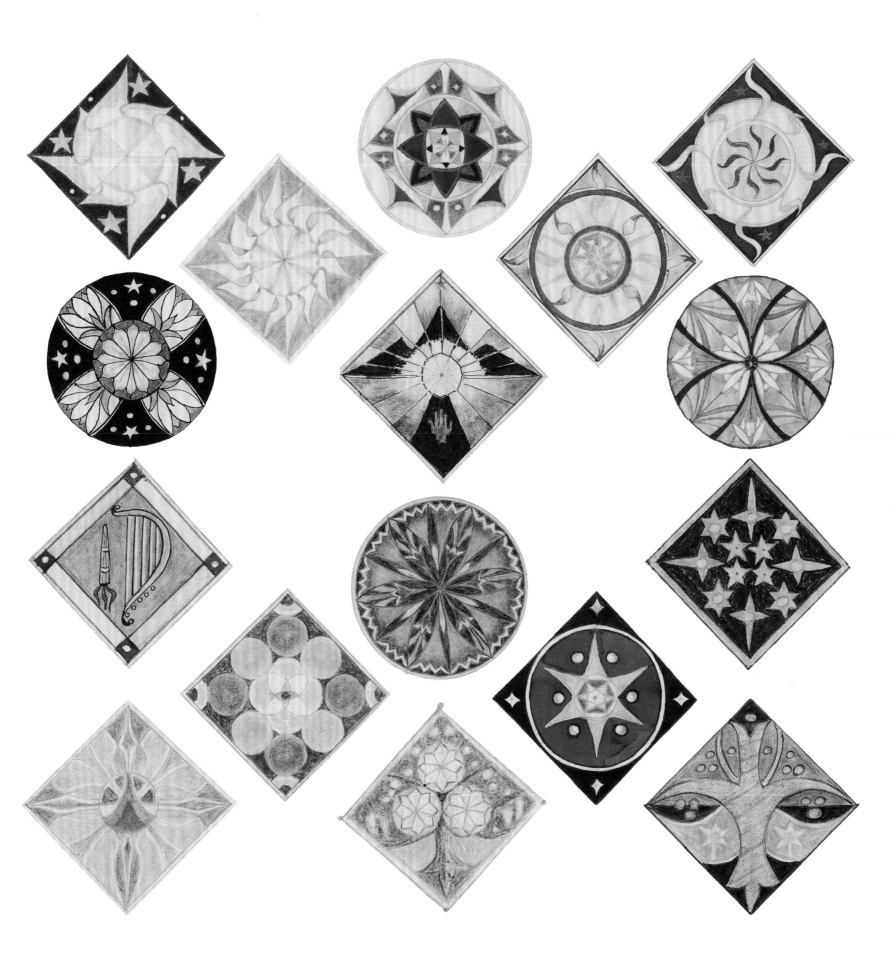

48. Elvish Script

The three pages of Elvish script here reproduced were published in *The Silmarillion Calendar 1978*. In substance they have no connection with *The Silmarillion*, being in fact the beginning of (versions of) the poems *Errantry* and *The Adventures of Tom Bombadil*. Those at the top and on the left are in the 'pointed' style; that on the right is in 'decorated verse-hand'.